HYDE PARK
The People's Park

Paul Rabbitts

AMBERLEY

To Ashley Rabbitts, I saved this one for you – London's greatest park for my greatest son.

Overleaf: The Great Exhibition of 1851. James Duffield Harding, 1798–1863. (© Yale Center for British Art, Paul Mellon Collection)

Opposite: Horses are a frequent sight in Hyde Park. (© Stuart Lee)

First published 2015

Amberley Publishing
The Hill, Stroud
Gloucestershire, GL5 4EP

www.amberley-books.com

Copyright © Paul Rabbitts, 2015

The right of Paul Rabbitts to be identified as the Author of this work has been asserted in accordance with the Copyrights, Designs and Patents Act 1988.

ISBN 978 1 4456 4288 8 (paperback)
ISBN 978 1 4456 4301 4 (ebook)

British Library Cataloguing in Publication Data.
A catalogue record for this book is available from the British Library.

Typesetting by Amberley Publishing.
Printed in the UK.

CONTENTS

ACKNOWLEDGEMENTS

This is my third book on the Royal Parks, following on from Regent's Park and Richmond Park. I had been keen to rediscover Hyde Park from the outset but, for one reason or another, the others preceded it despite the acknowledged history of this most famous of all the Royal Parks – the people's park. Indeed, it was George Orwell who wrote in 1945, 'In certain recognised open-air spaces like Hyde Park, you can say almost anything.' However, its full story has not been told for over eighty years, with only two books written solely about Hyde Park – *Hyde Park: Its History and Romance* by Mrs Alec-Tweedie in 1930 and *Hyde Park* by Eric Dancy in 1937. Both are dated and barely acknowledge the relationship with Kensington Gardens, which surely deserves a volume of its own. As with my previous books on Regent's Park and Richmond Park, my aim was to rediscover the early history of Hyde Park and capture the more recent history of this diverse and most dynamic of all the Royal Parks.

I have many to thank, including the following: Nicola Gale of Amberley Publishing for finally agreeing this park needed doing; Ruth Holmes from the Royal Parks, who simply has the best job in the country; Deborah Brady for capturing the essence of Hyde Park through her camera lens; Page, Plant, Bonham and Jones; and not forgetting my ever tolerant family who accompanied me to the greatest of William Pitt's 'lungs of London' – my wife Julie, youngest daughter Ellie and my eldest two, Ashley and Holly, who now live and study in London and understand and realise the importance of these wonderful open spaces, and enjoy them frequently.

The author and publisher would like to thank the following people and organisations for permission to use copyrighted material in this book: Stuart Lee, Tracy Crane, Dave Cutts, Grace Evangeline, Nick Howells, Franke Rooke, William Price, Chris Walts, Watford Museum, Debbie Brady and the Yale Center for British Art, Paul Mellon Collection. Every attempt has been made to seek permission for copyright material used in this book. However, if we have inadvertently used copyright material without permission or acknowledgement we apologise and we will make the necessary correction at the first opportunity.

Opposite: Autumn in Hyde Park.

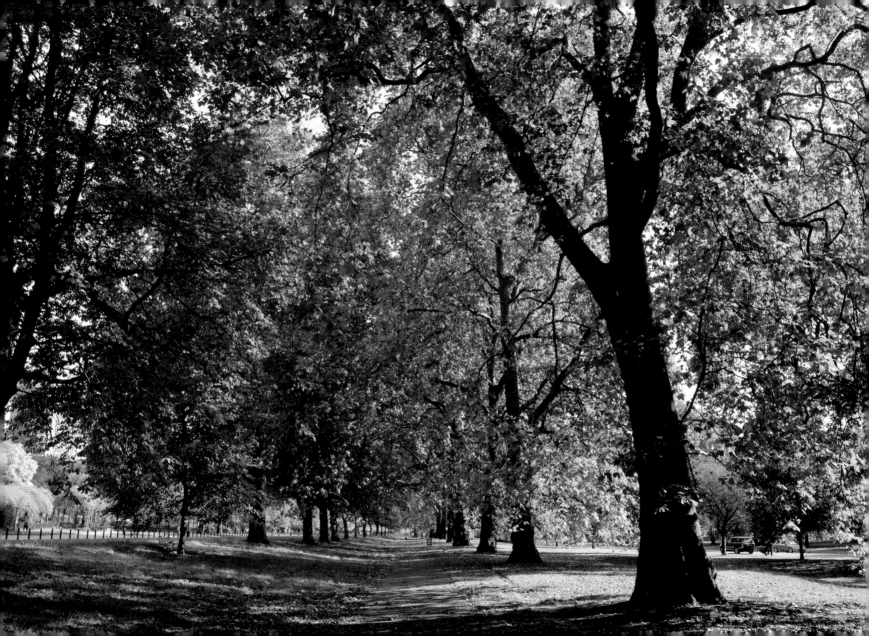

INTRODUCTION

In 1907, garden historian the Honourable Mrs Evelyn Cecil described London as having 'a peculiar fascination of its own, and to a vast number of English-speaking people all over the world it appeals with irresistible force ... the huge, unwieldy mass, which cannot be managed or legislated for as other towns, but has to be treated as a county, enfolds within its area all the phases of human life'.[1] London has changed significantly since her descriptions in 1907, although 'its seething millions at work' still remain, but thankfully 'its dismal poverty and relentless hardness' have somewhat dissipated. But Cecil is fulsome in her praise of London's parks and gardens. They are described as 'bright spots in the landscape ... beyond the pale of controversy; they appeal to all sections of the community, to the workers as well as the idlers, to the rich as well as to the poor, to the thoughtful as well as to the careless'.[2] She goes on to emphasise their importance in having a past full of historical associations, with the Royal Parks having a history and management of their own that means 'generation after generation of the world of fashion have passed beneath their shades'.

The importance of the Royal Parks to the history and development of London, the succession of monarchs who have hunted, met and celebrated within them and their evolution and importance to Londoners throughout the centuries cannot be underestimated. With nearly 1,000 years of history, dating back to 1086, from Tudor hunting grounds, scenes of bitter duels, immense feats of town planning, and world famous Zoological Gardens that have shaped the City of London, the story of the Royal Parks often reflects the very history of England; they have developed as London has developed, cultivated as much by the hand of the monarchy as by nature herself.

Leaping forward nearly seventy-five years, author and historian Hunter Davies is glowing in his praise of London's parks, which are indeed its 'greatest glory' and which 'offer so much, from playgrounds to palaces, Wren to Rembrandt, mausoleums to mosques, ponds to polo'.[3]

The Royal Parks remain, and have done for centuries, due to the long and continued benevolence of our reigning sovereigns. The monarchy has always acted as a deterrent towards any predatory disposition or attempts to deprive the freedom of the Royal Parks. What is apparent is that two much maligned monarchs were principal in their benevolence in the small matter of offering public access to crown lands – Henry VIII and Charles I.

Much has been written on these parks over many years, either as part of a wider story of the Royal Parks or often as a comprehensive history of each individual one. Strangely, Hyde Park has been neglected, with only two complete books dedicated to possibly the most famous and celebrated of all the Royal Parks. Both pre-date the Second World War and, although comprehensive, are now very much out of date. Yet Hyde Park is the most visited of all the Royal Parks, with over seven million annual visits, outstretching most of the London and indeed national visitor attractions.

Its history is a fascinating story. Author and historian Arthur Scammell, writing in 1917, refers to Hyde Park 'as the meeting-place of two worlds: a scene wherein the drama of eager human life goes on side by side with the slow, calm process of nature'.[4] The human picture is indeed a full one.

> High life and low life; kings following the chase, and outlaws hiding from justice; royal cavalcades and sorry processions to Tyburn; rank and fashion in daily parade, over against demonstrations of the unemployed; luxury in a royal palace, and tired destitution in uneasy slumber upon the park benches; loyalty doffing to the king, whilst over there the demagogue bellows in his tub; Rotten Row upon the one hand, upon the other the Reformer's Tree and there-erected Hyde Park railings. And between these extremes the constant coming and going of the multitude of decent citizens; not making history perhaps, but certainly making love; taking the air with their wives and children, or at the least, exercising their dogs. An epitome of London is Hyde Park. A pageant of English history.[5]

As Scammell leaves us, he summarises 'how many lives of city dwellers are enriched by hours passed thus, it is possible in part to realise the magnitude of the debt London owes to this beautiful pleasure ground'. Hyde Park is the most famous of them all, and London residents still persist in calling it 'the Park', as if no other park existed in our metropolis – no doubt because in the Stuart era, and even later, it was the only park that was truly open to the people at large. Despite the absence of houses and mansions, and therefore of actual inhabitants, it is almost as rich in historical recollections as any other part of London, or indeed any of the other Royal Parks.

Today, Hyde Park is now the most English of the Royal Parks. One can walk, lie on the grass, play games, take exercise and engage in sport, which even includes rowing on the Serpentine. Hyde Park has been described

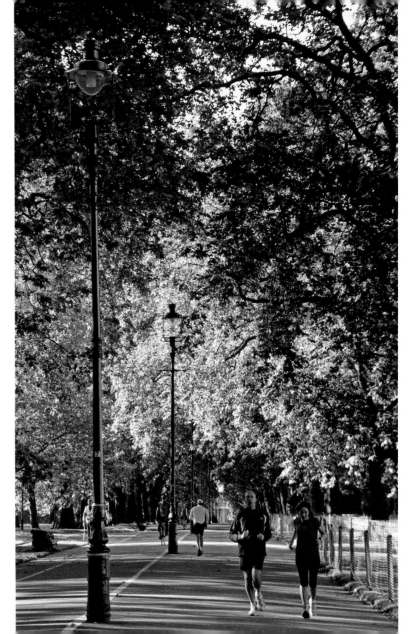

Joggers on the Broad Walk.

as 'nature's own plan, London's heritage from the prehistoric forest which surrounded *Londinium*' as well as 'the greatest People's Park in Europe'. The 'Lungs of London' are said to refer to the many parks and squares in London, and it conveys the idea of their importance to the well-being of its inhabitants. This was first attributed to William Pitt (1708 –78), Earl of Chatham, by Lord Windham, in a speech in the House of Commons on 30 June 1808, during a debate on encroachment of buildings upon Hyde Park. Windham said, 'It was a saying of Lord Chatham, that the parks were the lungs of London ...' Hyde Park is the chief of these 'lungs of London'.

This book tells the story of this incredible park with nearly 500 years of history, including the hiving off of several hundred acres to create Kensington Gardens and the succession of monarchs that have shaped it, enjoyed it and made it accessible to the many residents who continue to enjoy it to this day. Its impact on the history of London should not be underestimated – from royal hunting ground, to a Royal Park for the people, to perhaps the most famous park in the world today. This is the story of Hyde Park – the people's park.

A ROYAL HUNTING GROUND

At the time of the Roman conquest, all that was found on the banks of the Thames was a native settlement, which they called the 'Town of the Trinobantes' from the name of the people who lived there. This was a hyperbolic designation for a few hovels built of mud and branches, defended by a ditch and surrounded by forests. The town soon became a place of some importance, and before long its name was changed to *Londinium* and it was transformed into a walled town, located within the boundaries of the River Fleet, Cheapside and the Tower. Such was the beginning of the 'opulent, enlarged, and still increasing London'. The site of the future Hyde Park lay in the far west, in the midst of virgin forests, which for more than ten centuries afterwards continued to surround London to the north and the west. Wild boars and bulls, wolves, deer and smaller game, a few native hunters, swine-herds and charcoal-burners were in all probability the only inhabitants of those vast wildernesses.

Even in those remote times, London soon became an opulent city. Following the Romans were the Saxons, the Danes and ultimately the Normans. One of the most important of the Saxon dignitaries at the court of the Saxon kings bore the title of *Stalre* or *Stallere*, and held an office which appears to have been a combination of Master of the Horse, Constable and Standard-Bearer. The nobleman who held this position at the time of the Norman invasion was named Asgar, and from the Domesday Book it appears that he held numerous lands and manors. After the Conquest, William the Conqueror appointed Geoffrey de Mandeville, one of his noblemen, to succeed to all those lands which Asgar had held officially, but not to the property that he had inherited from his fathers. The manor of Eia appears to have come under the former category. This manor, extending to 890 acres, was situated in the parish of Westminster and the Hundred of Ossulston; it extended from the old Roman and military road (now Uxbridge Road and Oxford Street) down to the banks of the Thames, and included the site of the future Hyde Park within its boundaries.

At the time of the Domesday Book, the estate of Eia was divided into three manors: Neyte or Neate, Eubery and Hyde. Mandeville did not retain Eia for long, and on the death of his wife bequeathed it to Westminster Abbey. Of Hyde, little was known beyond the fact that the present Hyde Park occupies part of its site. Eyebury, Euberry, or Ebury, was situated towards Chelsea, eventually forming part of the property of the Marquis of Westmister. Neyte, on account of its proximity to the Abbey and to the river, became part of the estate that the monks preferred and was eventually used as a residence by some of the abbots, including Abbot Nicholas Litlington, who had significantly improved the property. So comfortable a place had the manor of Neyte become that John de Gaunt, so-called King of Castile and brother of King Edward III, took up residence there, requesting from the abbot permission to do so while Parliament was sitting in Westminster. The manor of Hyde had continued under the monks

for nearly five centuries, relatively undisturbed. Improvements had included cutting down some of the oaks and elms, clearing part of the forest and making some into pasture land. In the nearby forest there was pannage for their hogs and

> there also the merry abbots 'that loved the venerie', like him of the Canterbury Tales, could hunt the hart, the buck, and the doe, or, if inclined 'to ryde on hawking by the river with grey goshawk in hande,' there would be good sport of waterfowl on the banks of the small stream of the Eye Burn [the Tyburn], the West Bourne, and among the marshy pools.[1]

Little more than a century later, in 1592, Neyte had dwindled down to nothing more than the proportions of a farm.

But by 1536, Henry VIII, who was now courting Anne Boleyn, 'drove the poor monks from their snuggeries and claimed the church lands'.[2] On 1 July 1536, Henry VIII compelled the Right Reverend Father in God William Boston and the Convent of Westminster to hand over to him, 'with their whole assent, consent and agreement', certain lands, including Neyte, Ebury, Toddington and 'the syte, soyle, circuyte, and procyncte of the manor of Hyde, with all the demayne lands, tenements, rents, meadowes and pastures of the said manor, with all other profytes and comodities to the same appertaining or belonging, which now be in the tenure and occupation of one John Arnold'. In exchange for these lands, Henry gave over to the abbots the dissolved priory of St Mary at Hurley in Berkshire. Henry proclaimed,

> As the King's most royal Majesty is desirous to have the games of hare, partridge, pheasant, and heron preserved in and about the honour of his palace of Westminster, for his own disport and pastime, no person, on the pain of imprisonment of their bodies, and further punishment at his Majesty's will and pleasure, is to presume to hunt or hawk, from the palace

of Westminster to St Giles-in-the-Fields, and from thence to Islington, to Our-Lady-of-the-Oak, to Highgate, to Hornsey Park, and to Hampstead Heath.[3]

Henry's main object in appropriating this estate seems to have been to extend his hunting grounds to the north and west of London. He had previously purchased the land that afterwards became St James's Park. Marylebone (later Regent's) Park already formed part of the royal domain, and thus the manor of Hyde connected with these gave him an uninterrupted hunting ground, which extended from his palace at Westminster to Hampstead Heath.

As a result of this sequestration, it was probably around this time that the manor of Hyde was made into a park and enclosed with a fence or paling, becoming even more suitable for the rearing and preserving of game. Once enclosed, it was necessary to appoint a ranger or keeper to oversee it. The office of ranger of one of the Royal Parks was a sinecure to which, though the salary was small, there were attached various benefits such as free lodging and firewood, permission to hunt in the park and grazing of cattle. Such a post was usually conferred upon a royal favourite or someone who had served the country or king well. George Roper was the first keeper of Hyde Park, and appears to have been appointed at the Reformation, with a modest salary of sixpence a day. In 1553 Roper was succeeded by Francis Nevell and, for some unexplained reason, the keepership was divided between two. One lived in the lodge that stood on the site of the present Apsley House, the other more towards the centre of the park, probably in a building afterwards known as the Banqueting House, or the Old Lodge, which was eventually pulled down at the formation of the Serpentine in 1733. It was in 1574 that Queen Elizabeth appointed Henry Carey, first Lord Hunsdon, as Nevell's associate in the keepership, who would have full reversion of the office at the death of Nevell. He was described as a 'bold and high-spirited gentleman, very choleric, but not malicious, and

a lover of what our fathers were wont to call "men of their hands" – in other words, strong fellows, who could strike out from the shoulder in proper style'.[4] On Carey's death in 1596, his fourth son, Sir Edward Carey, succeeded to the office of keeper without any associate; this came with the use of all the houses, lodges and edifices, except the lodge and mansion with the herbage and pannage attached to it.

The condition of the park at this time is worth considering. In Nevell's time, in 1570, forty acres of land were attached to the park, which were railed in and enclosed. No cattle were allowed in as it was entirely reserved for the deer to graze in; the grass was grown and mown for hay to feed the deer in winter. Hyde Park, as in the time of Henry VIII, was still used as a hunting ground in the reigns of Edward VI, Elizabeth I and James I. In 1550, Edward VI was hunting in it with the French ambassadors. In January 1578, John Casimir, Count Palatine of the Rhine, the Duke of Bavaria and a general in the service of the Dutch paid a visit to Queen Elizabeth, lodged in Somerset House. Among the entertainments given was that of hunting at Hampton Court and shooting in Hyde Park, on which occasion it is chronicled that the Duke 'killed a barren doe with his piece from amongst three hundred other deer'. There are several accounts of Elizabeth hunting in Hyde Park. In 1588 she invited the Duke of Anjou to witness the sport in Hyde Park, and an entry is found in the records of the Board of Works 'for making of two new standings in Marybone and Hyde Park, for the Queen's Majesty and the noblemen of France to see the hunting'. These 'standings' must have remained, for John Norden alludes to them several years later – 'Hyde Park substancially impayled with a fayre lodge and princelye standes therein. It is a statelye parke and full of fayre game.'[5] In Elizabeth's time we also find the first mention of a review in Hyde Park, namely that held on the 28 March 1569, when her Majesty mustered there the Queen's Pensioners, who were 'well appointed in armour, on horseback, and arrayed in green cloth and white'.

In 1607, Carey was succeeded by Robert Cecil, Earl of Salisbury, with an adjunct also appointed in 1610 – Sir Walter Cope. For the first time an under-keeper, George Baynard, was also appointed. Robert Cecil was a younger son of Lord Burleigh, Queen Elizabeth's famous Lord Treasurer, and he himself was Lord High Treasurer to James I. Cope was the son of Edward Cope Esq., Master of the Wards and Chamberlain to the Exchequer, and was a significant landowner in Kensington. During their keepership many repairs and improvements were made in the park, including planting of trees, repairs to lodges, pales, fencing, standings and 'pond-heads'. On the death of the Earl of Salisbury, in 1612, Sir Walter surrendered the keepership of Hyde Park to his son-in-law, Sir Henry Rich, subsequently created Earl of Holland. A tragedy was to follow in 1619 when one of the gamekeepers was killed in an affray with two or three poachers. The unfortunate men were caught and executed. 'Even a poor labourer whom they had hired for sixteen pence to hold their dogs, shared the same fate.'[6]

James I was an excellent sportsman, even down to cock-fighting, but it was the hunt he relished most, enjoying 'a manlier diversion in the excitement of the hunt, refreshing himself between times at the banqueting house with a deep draught of good sack ere he returned to the Palace at Whitehall'.[7] King James was indeed a great hunter, and was a regular in Hyde Park with his favourite hounds, Jowler and Jewel. During his time and beyond there were eleven pools in the park. These pools and watercourses in Hyde Park used to supply various parts of London and Westminster with water. Various permissions were granted to carry water and 'convey the springs' in Hyde Park to the city of Westminster, and to lay pipes through the park for that purpose. But these were soon revoked in the reign of Charles I on the representations of the park keepers, who asserted that the ponds were so drained by these pipes that there was insufficient water remaining for the deer. Ignoring the petitions from the inhabitants of Westminster, who stated they knew the ponds were full, Charles took the word of his keepers,

preferring to see his subjects lack water rather than his deer. It was thanks to Charles I and entirely of his own free will that Hyde Park was eventually opened to the general public in 1637. There was some access well before that, with horse racing occurring in 1635 described as starting 'at the upper lodge, and to run the usual way from thence over the lower bridge unto the ending place at the Park gate'. The race is described in a play by James Shirley, written in 1637 and simply called *Hyde Park*. It contains some interesting descriptions of the park, with allusions to the singing of birds 'on every tree', including the cuckoo and nightingale. One of the races is a foot race, swiftly followed by a horse race. While they are waiting for the latter, a milkmaid goes round with milk, crying 'Milk of a red cow!' exactly as they continued to cry a century after at Milk Fair in St James's Park.

> This was refreshment for the 'musty superfluity'. Some desultory conversation, and the usual philandering ensues; the ladies bet scarlet silk stockings and Spanish scented gloves; a gentleman and a jockey talk about 'the cracks o' th' field' then there is a 'confused noise of betting within, after that a shout'. They start, and the betting goes on with breathless excitement.[8]

Charles I was a keen lover of sport and was frequently present at the races in Hyde Park. However, on one occasion he had an unfortunate disagreement with one Henry Martin, who was a member of Parliament. According to accounts of the time,

> Martin was a great lover of pretty girls, to whom he was so liberal that he spent the greater part of his estate. King Charles I had complaints against him for his wenching: it happened that Henry Martin was in Hyde Park one time when his Majesty was there going to see a race. The King espied him, and said aloud, 'let that ugly rascal begone out of the Park, that — —, or else I will not see the sport.'

Martin left but never forgot the insult, which apparently raised the whole county of Berkshire against the king. His revenge soon followed, when a few years later he signed his name next to Cromwell's on Charles's death-warrant.

During the first year of the Civil War, Parliament was becoming alarmed by the victories of the Royalists in a number of battles in northern and western counties. The outcome was the fortification of London. Early in March 1643, a Bill was passed ordering that the City and suburbs should be surrounded by a strong earthen rampart, with 'bastions and redoubts'. This was to be paid for by a house tax, at the rate of 6*d* on houses of a rent of £5 and 2*d* in the pound above. By this time, Hyde Park extended eastward to the site where Hamilton Place, running between Park Lane and Piccadilly, now stands. On this spot a large square fort with four bastions was erected. Such was the fear of the times that even ladies of rank – who encouraged and liberally supplied with provisions the men who worked on these forts – took up the spade and the bucket, the pickaxe and shovel, and worked in the trenches. They

> Marched rank and file, with drum and ensign,
> To intrench the City for defence in:
> Raised rampiers with their own soft hands,
> To put the enemy to stands;
> From ladies down to oyster wenches
> Labour'd like pioneers in trenches,
> Fell to their pick-axes and tools,
> And help'd the men to dig like moles.[9]

The fort at Hyde Park Corner remained standing for four years and was demolished in 1647 by order of the House of Commons, as there was no further use for it. At the north-eastern corner of Hyde Park 'a court of guard' was erected, where a close watch was kept over all who went along the road to Oxford, where the court then resided. Among their duties

was the prevention of such incidents as that wich occurred when, owing to the great shortage of fuel among the population, 'several unruly and disorderly persons have in a tumultuous and riotous manner, broken into Hyde Park and pulled down the pales, to destroy his Majesty's deer and wood there'. This disrespect for the king's property while they were at war with his 'sacred person' was highly characteristic. Again it was ordered 'that no soldier or other person whatsoever, shall presume to pull down or take away any of the pales belonging to the said Park, nor kill or destroy any deer therein, nor cut, sell or carry away any wood growing in or about the said Park or mounds thereof.'[10]

During such turbulent and riotous times the park was still the place to be seen, especially for the fashionable and lovers of fresh air and exercise. But this was to change in 1645, when orders were given 'that Hyde Park and Spring Gardens should be kept shut, and no person be allowed to go into any of those places on the Lord's day, fast, and thanksgiving days, and hereof those that have the keeping of the said places are to take notice and see this order obeyed, as they will answer the contrary at their uttermost peril'. Even on permissible days, the days of gaiety and festivity were few and far between. The use of the park for hunting became less and less and new areas were converted into grasslands.

On 6 August 1647 the Parliamentary troops under Fairfax marched through Hyde Park from Holland House with laurel branches in their hats, after resolving their differences with the Londoners, with whom there had been considerable ill-feeling. In Hyde Park, the Lord Mayor and Aldermen met General Fairfax 'to congratulate the fair composure between the city and the army'. The following December, Lord Essex and Colonel Lambert were encamped in the park. On 9 May 1649, Cromwell reviewed his regiment of Ironsides and Fairfax's regiment of

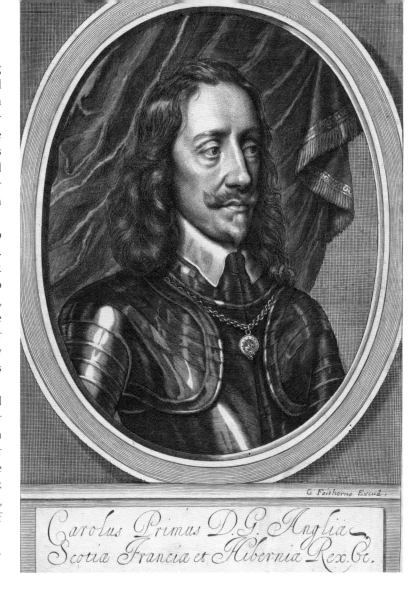

G. Faithorne Excud.

Carolus Primus D.G. Anglia
Scotia Francia et Hibernia Rex. &c.

Charles I, 1658. Print made by William Faithorne, c. 1620–91. (© Yale Center for British Art, Paul Mellon Collection)

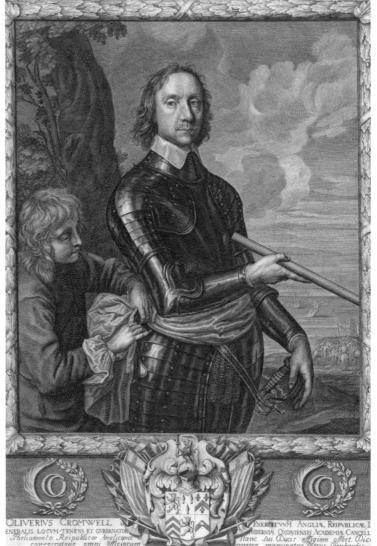

Far left: A London dandy of 1646.

Left: Oliver Cromwell. Peter Lombard, 1612–82. (© Yale Center for British Art, Paul Mellon Collection)

horse. Insubordination was rife in the ranks and Cromwell addressed them, explaining the great care and pains of Parliament in the execution of justice against delinquents. He concluded by saying 'that those who thought martial law a burden, were at liberty to lay down their arms, and receive their tickets, and would be paid their arrears as fully as those that staid'. The effect was positive and the men's conduct improved. A further military pageant was held in Hyde Park on 31 May 1650, again attended by Cromwell, when he was met on Hounslow Heath by many members of Parliament and officers of the army. As he passed through Hyde Park on his way to Whitehall the great guns fired salutes, while Colonel Backstead's regiment, which was drawn up, fired a volley.

As the park in essence was no longer royal property, from the moment the king had retired from London to make war against his subjects, Parliament appointed a new keeper over it. The Earl of Holland, the late keeper, had requested in 1630 that the reversion of his office might be granted to Mountjoy Blount, Earl of Newport (subsequently Earl of Warwick and Lord Gray), and afterwards to Sir John Smith on the death of his lordship; but in 1648 the Earl of Northumberland proposed in the House of Lords that Lord Howard of Escricke should be appointed to the keepership. The Earl of Warwick objected, and wrote to the Speaker to inform him that he had an assignment of the keepership from Lord Holland and desired to be heard by his counsel before the place should be disposed of. On receipt of the letter the Lords revoked their recommendations of Lord Howard of Escricke, and the Earl of Warwick had the office granted to him on 20 March 1649. His keepership did not last long. The year after Charles I was beheaded, it was resolved in Parliament that Hyde Park and St James's Park, along with other royal mansions and parks (Whitehall, Hampton Court, New Park at Richmond, Westminster Palace, Windsor House and Parks and Greenwich Park), should be kept for the use of the Commonwealth and be thrown open to the public. This was revoked three years later in November 1652 when the House of Commons 'resolved that Hyde Park

be sold for ready money'. Included were also Bushy Park, Greenwich and Windsor Park. Hyde Park was to be sold in three lots. The purchasers of the lots were Richard Wilcox of Kensington, John Tracey of London and Anthony Dean of St Martin's-in-the-Fields. Descriptions are revealing and include 'a building intended at its first erection for a banqueting-house', as well as the Old Lodge that was situated near Hyde Park Corner, which had barns and stables and several tenements near Knightsbridge attached to it. Prices paid for woodland give the impression that the north-western part of the park was thickly wooded, while the parts towards Kensington were meadow-ground, enclosed for deer. These were still numerous and highly valued as part of the sales.

Despite the park now being in private ownership, it still continued to be popular with visitors. In April 1653, diarist John Evelyn visited. 'I went to take the air in Hyde Park, when every coach was made to pay a shilling, and horse sixpence, by the sordid fellow who had purchased it of the state, as they were called.' Despite the displeasure of the Puritans, May Day continued to be popular, especially in Hyde Park. It was the place to be seen in all one's finery, despite entrance money being levied at the gate. Such a May Day was reported in 1654 by one of the local papers, which wrote,

> This day was more observed by people going a-Maying, than for divers years past, and, indeed, much sin committed by wicked meetings with fiddlers, drunkenness, ribaldry, and the like. Great resorts came to Hyde Park, many hundreds of coaches, and gallants in attire, but most shameful powder'd-hair men, and painted and spotted women. Some men played with a silver ball, and some took other recreation. But his Highness the Lord Protector was not thither, nor any of the Lords of the Council, but were busy about the great affairs of the Commonwealth.[11]

In fact Cromwell was in attendance, often appearing alone or surrounded by bodyguards, dressed in grey frock-coats with velvet welts. However, on

one occasion Cromwell had a more serious visit which was almost fatal. Suffering from an illness, his physicians had recommended him to take exercise, which he did as often as he could. In the beginning of October 1654 he was taking his usual drive in Hyde Park, and as he was not one to 'excel in guiding a chariot to the goal' an accident happened to him which almost proved costly.

> He caused some dishes of meat to be brought, where he made his dinner, and afterwards had a desire to drive the coach himself, having put only the Secretary into it, being those six [grey] horses, which the Earl of Oldenburgh had presented unto his Highness, who drove pretty handsomely for some time. But at last, provoking those horses too much with the whip, they grew unruly, and ran so fast that the postillon could not hold them in; whereby his Highness was flung out of the coach-box upon the pole, upon which he lay with his body, and afterwards fell upon the ground. His foot getting hold in the tackling he was carried away a good while in that posture, during which time a pistol went off in his pocket: but at last he got his foot clear, and so came to escape.[12]

Cromwell was out of action for several days as a result of the accident. It was not the only time that his life was endangered in the park. He was shot at when he was returning from Richmond to London; '[the conspirators] went out seven times for the purpose of shooting him ... they went thither heavily armed, and that the hinges of the Park gate were filed in order to facilitate their escape.' Again, Cromwell survived unscathed. The last incident of any note within the park during the Commonwealth was a coach race on 20 May 1658, which became a national sport. Cromwell died the same year.

During the last years of the Commonwealth, Hyde Park became a sorry place and much neglected. The following is an extract from *A Character of England, as it was lately presented in a Letter to a nobleman of France* (1659), attributed to Evelyn.

> I did frequently in the spring accompany my Lord N. into a field near the town, which they call Hyde Park; the place not unpleasant, and which they use as our *Cours;* but with nothing of that order, equipage, and splendour, being such an assembly of wretched jades and hackney coaches, as next a regiment of Carmen, there is nothing approaches the resemblance. This Park was, it seems, used by the late King and Nobility for the freshness of the air, and the goodly prospect: but it is that which now (besides all other excises) they pay for here in England, though it be free in all the world beside; every coach and horse which enters, buying his mouthful, and permission of the Publican who has purchased it, for which the entrance is guarded with porters and long staves.[13]

After the general elections of 1660 the restoration of the royal family began to be openly discussed, although there were significant concerns that this restoration would not be brought about peaceably. Pepys wrote on May Day 1660, '[I] wished myself in Hyde Park,' while in a cabin of the ship *Naseby*, lying off Deal, which flew the Royal Standard and was one of the ships sent to escort King Charles II from Holland back to England. That first of May was a glorious day for Hyde Park, more glorious than any had been for many years. The Puritans had been defeated and discredited and their strict notions – their hatred of dress and display – banished for good. Hyde Park once again took on glorious colours. 'It had been characteristic of the cavaliers to dress in silk and satin, lace and ribbons to revel in "unlovely love-locks", fluttering feathers, and jingling spurs, while the sober-minded Puritan wore his slouched hat, his hair cropped short, and went about in plain sad-coloured cloth, with a Bible suspended from his girdle.'[14]

Charles II made his triumphant return to London on his birthday, 29 May, and immediately set about imitating the life, luxury and magnificence he had seen so much of at the court of Louis XIV. Hyde Park soon became again what it had been before the Civil War – the rendezvous of fashion. Parliament had never ratified the sale of Hyde Park, which was now nullified by the courts

of law. Mr John Tracy, one of the purchasers of the park, pleaded that he had been a merchant in Holland for thirty-eight years and had just returned to England in 1652, ignorant of the affairs of the State, when he bought the Crown lands. He further stated, in his exoneration, that he had preserved the timber and planted the ground, in consideration of which all he asked was the grant of two houses, which he built on the road to Knightsbridge. Anthony Dean was also forgiven, and was subsequently promoted and made Surveyor-General of the Shipyards, 'a place of great trust as well as profit'.

Charles enclosed Hyde Park with a brick wall and made it the open-air fashion centre of London. In approximately the middle of the park at that time was a round paling called the Tour, or more generally known as the Ring, set in a square of trees, and it was here that fashion gathered to ride and drive; the *monde* just went round and round. A foreigner writing about English life several years after Charles said,

> They take their rides in a coach in an open field where there is a circle, not very large, enclosed by rails. There the coaches drive slowly round, some in one direction, others the opposite way, which, seen from a distance, produces a rather pretty effect, and proves clearly that they only come there in order to see and to be seen. Hence it follows that this promenade, even in the midst of summer, is deserted the moment night begins to fall, that is to say, just at the time when there would be some real pleasure in enjoying the fresh air. Then everybody retires, because the principal attraction of the place is gone.[15]

The actual origins of the Ring is not certain, but it is possible that it was a remnant from the garden of the old banqueting house which had been pulled down, or it may have been erected by two speculators who had hired the ground from Anthony Dean and levied a toll. The latter

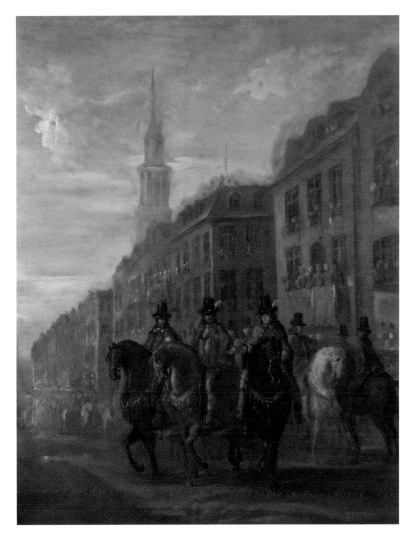

Restoration Procession of Charles II at Cheapside, 1745. William Hogarth, 1697–1764. (© Yale Center for British Art, Paul Mellon Collection)

is, however, the most unlikely. In 1719 the Ring is described by a French traveller as being 'two or three hundred paces in diameter, with a sorry kind of balustrade, or rather with poles placed upon stakes, but three feet from the ground, and the coaches drive round this.' At the turn of the twentieth century, remnants of the Ring were still traceable, with a small number of old trees on the spot where it existed. These trees were ancient enough to have formed part of the identical trees round which 'wits and beauties' drove in their carriages and 'in their rotation exchanged as they passed, smiles and nods, compliments or smart repartees'.

On the second May Day of the 'blessed Restoration', Pepys was once again missing Hyde Park as he was on his way to Portsmouth, and

Charles I created a circular track called the 'Ring', where members of the royal court could drive their carriages.

wrote, 'I am sorry I was not at London to be at Hyde Park to-morrow, among the great gallants and ladies, which will be very fine.' What made it worse for poor old Pepys was that his graver friend Evelyn had been there 'to take the air', while 'there was his Majesty and an innumerable appearances of gallants and rich coaches, being now a time of universal festivity and joy'.

It was also at this time that Hyde Park became the favourite place for reviews. Within months of Charles II ascending to the throne, he had remodelled the Trained Bands, increasing them to 20,000 men and 800 cavalry. Once fully reorganised, Charles reviewed them in Hyde Park, accompanied by 'divers persons of quality and innumerable other spectators, to general satisfaction'. The following year, 1661, was an even greater spectacle. Will Wood, the best bowman of his time, described the performance, saying, 'Four hundred archers with their bows and arrows made a splendid and glorious show in Hyde Park, with flying colours and cross-bows to guard them.' Charles held military reviews in Hyde Park, with the first recorded on 27 September 1662, when he inspected the newly formed Life Guards, consisting partly of Cavalier soldiers. It was his first attempt at raising a standing army and certainly succeeded in stirring the hearts of many a female as the soldiers strode past 'his Sacred Majesty, the butts of their carbines on their thighs and their crimson silken standard floating in the Royal air'.

On his accession, Charles II appointed his youngest brother Henry, Duke of Gloucester, as keeper of the park, on 28 June 1660. Sadly, he was only in this position for a matter of weeks before he died of smallpox in September. Shortly after his death, James Hamilton Esq. – nephew to the Duke of Ormond as well as Groom of the Bedchamber – was appointed. Hamilton received a number of benefits in connection with the park and this included the triangular piece of land between the Lodge and the present Park Lane. During the Commonwealth, the fort and various houses had been built here. Hamilton was tragically shot in an

engagement with the Dutch in 1673, after which the king renewed the lease for ninety-nine years to his widow. It was under Hamilton that the park was enclosed with a brick wall and was once again stocked with deer. Sir Charles Harbord, Surveyor-General of the Works, wrote in 1664 that the king was 'very earnest with him for walling Hyde Park in, as well for the honour of his palace and great city, as for his own disport and recreation.' Hamilton was certainly speculative, as seen from his building transactions. One of his ventures was to grow apple trees in Hyde Park and the land granted to him was described as 'ditched and severed from the Park, and lying in the north-west corner thereof, bounded on the north by the Uxbridge way, on the west with the lands of Sir Heneage Finch (now Kensington Gardens), and on the south and east by the said Park'. The conditions of the grant included that the king was to 'have one-half of the apples there grown, at his own choice either in apples or in cider. If in the latter form, his Majesty was to find the bottles and casks.'

Tragedy was to hit London in 1665, the year of the Great Plague. Many left London, but those who remained were dying at a rate of over 8,000 a week, with 38,195 deaths between 22 August and 26 September alone. To protect them from the ravages of the plague, the Duke of Albemarle took his troops to Hyde Park and encamped them there. Two years later, London was returning to some degree of normality, with new houses arising out of the ruins of those that had been burnt to the ground in the Great Fire of 1666, and as a result, 'new beauties came out every season, to step into the place of those who had not been carried off by death, or marriage, or what not'. Among those that reappeared was the merry Pepys. He was there on 3 June 1668. 'To the Park, where much fine company and many fine ladies, and in so handsome a hackney I was, that I believe Sir W. Coventry and others who looked on me, did take me to be in one of my own, which I was a little troubled for; so to the Lodge and drank a cup of new milk, and so home.' The lodge he refers to was one of two, with this one being in the middle of the park, in which one of the keepers resided, the other being near Hyde Park corner. In Charles II's time this was a drinking house and was sometimes known as Price's Lodge, named after Gervase Price, the chief under-keeper. It is frequently referred to as 'the Lodge in Hyde Park' and in Queen Anne's time as the Cake House, Cheesecake or Mince-pie House, and was frequented by the belles and beaux of the time. A timber-and-plaster building, it was eventually taken down in the early part of the nineteenth century.

By September 1668, there was a grand military pageant in the park, which Pepys again describes.

> When I came to St James's, I find the Duke of York gone with the King, to see the muster of the Guards in Hide Park; and their Colonell, the Duke of Monmouth, to take his command this day of the King's Life Guard, by surrender of my Lord Gerard. So I took a hackney coach, and saw it all: and indeed it was a mighty noble, and their firing mighty fine, and the Duke of Monmouth in mighty rich clothes; but the well-ordering of the men I understand not. Here among a thousand coaches that were there, I saw and spoke to Mrs Pierce.

In 1669 Pepys at last drove in his own coach, seeing things somewhat differently.

> *11th 1669.* Thence to the Park, my wife and I, and here Sir William Coventry did first see me and my wife in a coach of our own, and so did also this night the Duke of York, who did eye my wife mightily. *2fifth April 1669.* Abroad with my wife in the afternoon to the Park, where very much company, and the weather very pleasant. I carried my wife to the Lodge, the first time this year, and there, in our coach, eat a cheesecake and drank a tankard of milk. I showed her also this day first the Prince of Tuscany, who was in the Park, and many very fine ladies.

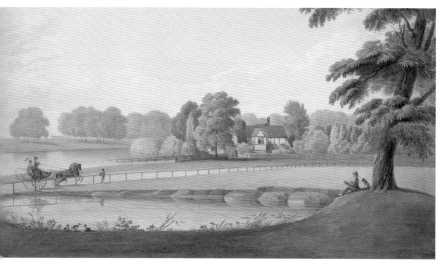

On the last day of May, Pepys's last entry in his diary described a visit with his wife and some friends to the park and 'thence to the World's End, a noted drinking-house which he and the other choice spirits of that day frequently patronised'.

One of the last events that Charles II attended in the park was on 28 January 1682, when 'the Guards went through their evolutions in honour of the Ambassadors of the Sultan of Morocco. The soldiers were gallantly, and the officers magnificently accoutred.'[16]

James Hamilton was the last ranger of Hyde Park as a separate entity. Charles II had thrown St James's Park open to the public, and subsequent keepers of that park appeared to have Hyde Park under their supervision. Hamilton was present at an engagement with the Dutch on 4 June 1673, when one of his legs was shot off by a cannonball. He died as a result of his wounds and was buried in Westminster Abbey. Nobody was appointed in his place until 1684, when the office, under its new denomination of Ranger of St James's Park, was conferred upon William Harbord Esq. of Cadbury in Somerset, MP for Launceston in Cornwall, and son of Sir Charles Harbord, who had been Surveyor-General under Charles I. He was frequently referred to in the many writings of Pepys.

Towards the end of the seventeenth century, Hyde Park was no longer a royal hunting ground. Certainly in 1664, deer were still in the park and the king was 'very earnest … for walling Hyde Park in, as well for the honour of his palace and great city, as for his own disport and recreation'. However, by the reigns of James II and William III, Hyde Park was very much in essence a Royal Park for the people.

Above: The Cheesecake House, Hyde Park. Thomas Theodosius Forrest, 1728–84. (© Yale Center for British Art, Paul Mellon Collection)

Below: The Cheesecake House, Hyde Park. Unknown artist (eighteenth century). (© Yale Center for British Art, Paul Mellon Collection)

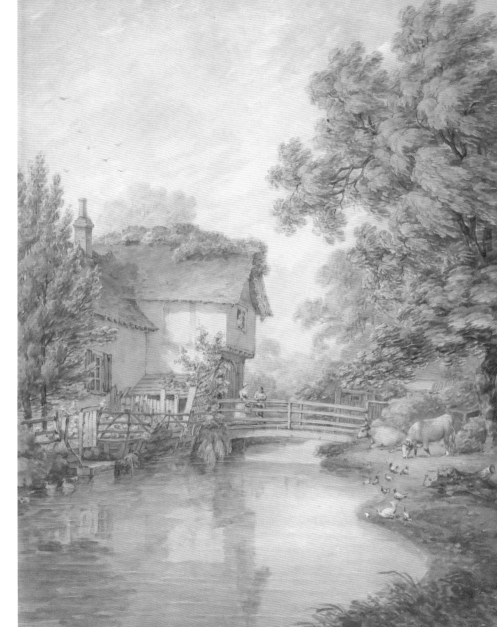

The Cheesecake House, Hyde Park, 1795. Thomas Hearne, 1744–1817.
(© Yale Center for British Art, Paul Mellon Collection)

A ROYAL PARK FOR THE PEOPLE

The reign of James II offered little in the way of changes to Hyde Park. It was his successor William III, a man of delicate health, quiet and reserved of mind, that had the greatest impact locally. Whitehall and St James's were too noisy for this placid little Dutchman, and as a result he bought the nearby manor of Kensington from the Earl of Nottingham, altered it so it became more appropriate as a royal residence, and spent as much time as he could there. However, the royal road from St James's to Kensington Palace ran through the Green and Hyde Parks and, as his Majesty often passed along it after dark, he ordered three hundred lamps to be placed by its side. This was the first instance of a public road being lit up in such a way and was described at the time as 'very grand and inconceivably magnificent'. But this was only a winter luxury, with the lamps removed during summer. The real issue at the time, which beset travellers through the park, was highwaymen. As early as the reign of Charles II, the salubrious and pleasant situation of Kensington had rendered the village a favourite suburban retreat for the aristocracy, and it became more popular when William III took up his residence in Kensington Palace. The consequence was that fashionable people on their way to and from theatres and assemblies had to pass through the park, and there, unless their carriage was well attended by armed servants, the highwaymen lay in wait for them. So common were these robberies that William III ordered the guards to patrol the park until eleven o'clock at night, when he turned the palace into a casino with basset tables. Patrols were then doubled so that the gentlemen might have some chance of carrying home their winnings unmolested. In addition to this, a guard-house was built in the park in 1699, 'for securing the road against the footpads, who continue to be very troublesome'.[1] William and Mary seldom appeared in the park themselves except to attend reviews, and it would seem that the park missed their presence and the company in the Ring, deprived of the 'fostering smiles of royalty', appeared to have somewhat degenerated. According to Tom Brown's accounts, there were 'bevies of gallant ladies, some singing, others laughing, others tickling one another, and all of them toying and devouring cheesecakes, marchepane, and china oranges'.[2]

In 1694 William Harbord was succeeded in the keepership by William Henry Granville, the third Earl of Bath, who occupied the office for only six years. In 1700 Edward Villiers, the first Earl of Jersey, was appointed his successor. He was several times ambassador to Holland and France, and after having occupied various other high and lucrative offices gave up all public employment in 1704, and died in 1711. A lease was granted to this earl for a lodge with land and gardens in Hyde Park, for fifty-one years. In 1703, he was succeeded by Henry Portman, cousin and heir of Sir William Portman, a Tory gentleman of great note who had commanded the Somerset militia against the Duke of Monmouth in 1685. Portman died without issue on 24 January 1719, leaving his estate to a sister's son.

At the time, France was still considering invading England in support of a Jacobite rebellion, and there was a plan to assassinate William while he was in Holland in 1692. Mary, being appraised of these plans, turned the Papists out of London and personally held two military reviews in Hyde Park. Many such reviews were held during the reign, and there was a particularly large one on 9 November 1699, with the 'glorious appearance' of the Life Guards' new uniforms. The king was accompanied at this review by the Prince of Denmark (husband of the future Queen Anne), the Duke of Schomberg and the Earl of Marlborough, who later became Duke. Three troops mustered, and the king 'took particular notice of each gentleman' as they filed before him. There was Ormond's troop, mounted on black horses, with richly laced scarlet coats, white feathers and great knots of ribbon, tagged at the end, on the side of their hats. The other two troops, commanded by Earl Rivers and the Earl of Albermarle, were dressed similarly, but with red and green feathers respectively. According to the *London Post,* 'They appeared by account of all the spectators, to be the finest body of men and the compleatest cloathed and accoutred in the world.' There were 20,000 spectators, including one Mira, who seemed to have a great effect on the troops; among them, according to Granville, she 'dealt destruction's devastating doom'. This lady seems to have had a happy, haughty way about her, and a useful penchant for massacre, as Granville explains in his poem 'Mira at a Review of the Guards in Hyde Park'.

> Let meaner beauties conquer singly still,
> But haughty Mira will by thousands kill:
> Thro' armed ranks triumphantly she drives,
> And with one glance commands a thousand lives.
> The trembling heroes nor resist, nor fly,
> But at the head of all their squadrons die.

Since the reign of Charles II, the Mall in St James's Park had become a rival to the Ring, although the latter still had the better reputation. The Ring had the advantage that it gave the opportunity for displaying a carriage, horses and smart livery. Equipages at that time became more and more fashionable, and to be seen afoot in the Mall was considered by many to be the height of vulgarity. During Queen Anne's reign, the Ring still continued to be the place to be seen. 'No frost, snow, nor east wind can hinder a large set of people from going to the Park in February; no dust nor heat in June. And this is come to such an intrepid regularity, that those agreeable creatures that would shriek at a hind-wheel in a deep gutter, are not afraid in their proper sphere of the disorder and danger of seven crowded Rings.'[3]

> The Ring was an unending stream of heavily gilded, scarlet-lined coaches, with arms emblazoned, driven by portly coachmen and each drawn by six hefty Flanders mares. Silken footmen with cone-shaped caps, tasselled and spangled, trotted along in front on foot, carrying long silver-headed canes. The proud and round-bosomed ladies who rode in the coaches vied with one another in fatness and stuffed their cheeks with plumpers when food and lack of exercise did not develop them enough.[4]

The *Tatler, Spectator* and plays of the period alluded constantly to the brilliant company that assembled on the Ring, around which a full tide of gaudily dressed human beings daily whirled.

Up to this time, with the exception of the poor hanged poachers, the park had been host primarily to 'brilliant shows, pageants, and popular diversions'. These continued throughout the eighteenth century, but were interspersed with scenes of murder and bloodshed. As London grew, many of these most popular places were too often frequented by gentlemen who wished to settle their differences in a friendly manner, by means of 'a yard of cold steel'. Hyde Park was a convenient distance from town, was unfrequented in the early

hours of the day and there were quiet, snug corners where 'the turf was smooth, and the soil firm and elastic, – in a word, it was a most desirable place for … dying of honour.' One of the first to come to Hyde Park for such a confrontation was a certain Captain Steele of the Guards, who, on 16 June 1700, ran a Captain Kelly through the body. On 7 December the same year, a Colonel Edward Colt was killed on the same spot in a duel with a Captain Swift. It is probable that duels were commonplace even earlier than this. The most likely location of such clashes was a little south of the Ring, near the Serpentine. It was close to this spot on the 15 November 1712 that a fatal but notorious duel took place between James, fourth Duke of Hamilton, and Charles, Lord Mohun. The duke was an eminent Tory, having been appointed ambassador to the court of Versailles, where the Old Pretender resided. The Whigs were greatly alarmed and resolved to get rid of the new ambassador by 'fair means or foul'. A duel appeared to be the most simple but effective means of achieving this. Lord Mohun, the Hector of the Whig party, had been for a long time involved in a long, tedious and expensive lawsuit with the duke. At first, the duke had no desire to become involved with such a disreputable character, but eventually a meeting was set up between them and their seconds. The duel was fought with swords, the seconds engaging as well as the principals, as was then the custom. Mohun's second, General Macartney, wounded his opponent, Colonel Hamilton, who was disarmed, and the fight between them was brought to an end. But Mohun and the duke were still lunging at each other with uncommon ferocity, both bleeding from several sustained wounds, which reddened the grass surrounding them. At last both made a thrust, but at the same time; the duke's sword passed through his adversary up to the very hilt, and the latter, with still enough strength remaining, shortened his weapon and plunged it into the duke's left breast, after which both fell to the ground. The keeper of Price's Lodge lifted the duke up and helped him walk about thirty yards, when he said he could walk no further and expired almost immediately. In the meantime, Mohun had fallen on his back into a ditch and died on the spot. His body was brought back to his house in Marlborough Street in the same hackney carriage which had taken him to Hyde Park, where it was said that his lady was 'vastly displeased at the wet, bloody corpse being laid upon the best bed and spoiling her Chinese counterpane.' Macartney fled to Holland, having being accused by Colonel Hamilton, on oath, of having stabbed the duke through the heart over the Colonel's shoulder, while he was raising him from the ground. The Tories went even further, and asserted that the Whigs had placed hired assassins in the park to kill the duke in case he had escaped alive. The general eventually returned voluntarily to stand trial and was found guilty of manslaughter, at which time Hamilton fled to avoid prosecution for perjury.[5] Mohun and Hamilton had suffered such horrific injuries that the government eventually passed legislation banning the use of seconds in such duels. Also, swords were replaced by the pistol as the weapon of choice in duels, which resulted in shorter and less bloody fights.

At the end of 1714, there were serious Jacobite riots in London, which spread throughout the country. 'No Hanover' and 'No Foreign King' were the popular cries. In order to safeguard London, and to intimidate the devotees of the Stuart family in the metropolis, it was thought advisable to concentrate a strong body of troops in its immediate vicinity. A camp under the command of General Cadogan was formed in Hyde Park on 16 July 1715, occupying the south side of the park and consisting of the Life Guards and Horse Grenadiers, the regiment of the Duke of Argyle and three battalions of Footguards, besides twelve pieces of cannon and several wagons of ammunition from the Tower.

On 1 August, the anniversary of George I's accession to the throne was celebrated with great rejoicings and the Foot Guards paraded in new clothing. The day was concluded with bonfires, illuminations and much celebratory drinking. The tents in the park were eventually replaced by huts for the soldiers, while wooden stables were erected for the horses. The festivities on the birthday of the Prince of Wales on 3 November surpassed even those of 1 August. In the evening the soldiers were assembled within

illuminated circles, and drank various loyal toasts with 'considerable emphasis, expressed by loud cheers and huzzas, whist volleys of cannon and small arms followed each toast'.[6] After the defeat of the Jacobite army at Sheriffmuir, and their surrender at Preston, the camp was no longer necessary, and the troops returned to their respective quarters. Further reviews were held in the park with one in particular attended by Prince George, who told the officers that 'he could now send his father word that he had reviewed his Guards, and found them the finest body of men in person and appearance that the world can produce'.

Military executions were a somewhat regular occurrence in Hyde Park. For such crimes as petty larceny, insubordination and ordinary desertion, soldiers used to be tied to a tree and soundly flogged. More serious transgressions resulted in the perpetrator having to run the gauntlet or be whipped in both Hyde and St James's Park. For very serious offences they were shot, their bodies returned to their friends or buried by the park wall. The spot where they were executed is represented on Rocque's plan of London, published in 1749, where it is marked as 'the stone where the soldiers are shot'.

In 1722, the Jacobites and Tories were once again fuelling rebellion and conspiring against the existing government. Camps were formed across the country with troops constantly placed in readiness for action. In May, a site was marked out for the Household Brigade in Hyde Park and on Tuesday 8 May the three regiments of Foot Guards marched to take up their ground in the park. A fair soon arose on the outskirts of the camp, 'adorned with quaint signs, dancing saloons, puppet shows, posture-mastures, the famous Mr Fawks ... besides French billiards and dice for the *gens de qualité,* and many other amusements.' Reviews and continued festivities were commonplace and the satirists of the time had plenty to

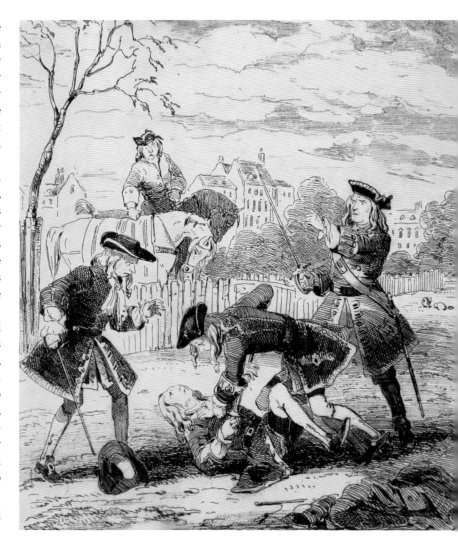

The duel that took place in the year 1711, between the Duke of Hamilton and Lord Mohun, in which, unhappily, both the principals fell.

write about, mostly uncomplimentary. One scribbler writes of the horror of discovering an officer as no engineer but 'an effeminate tea-drinker' and another who falls foul of the belles of the day 'for their ridiculous walking in red cloaks like soldiers'. The Ring, as long as the camp existed, remained desolate. Titled ladies, as well as city dames and town madams, were constantly hovering about the tents. Officers and soldiers were keen to invite the ladies in to inspect their tents and treated them to 'a dish of tea, or a dram of ratafia'. Pope wrote at the time,

> Women of quality are all turned followers of the camp in Hyde Park this year, whither all the town resort to magnificent entertainments given by the officers. The Scythian ladies that dwelt in the waggons of war were not more closely attached to the baggage. The matrons, like those of Sparta, attend their sons to the field, to be witnesses of their glorious deeds; and the maidens, with all their charms displayed, provoke the spirit of the soldiers. Tea and coffee supply the place of the Lacedemonian black broth. This camp seems crowned with perpetual victory, for every son that rises in the thunder of cannon, sets in the music of violins. Nothing is yet wanting but the constant presence of the Princess to represent the *Mater Exercitus.*

The growth of London in a westerly direction had long meant that an ample supply of water was an essential requirement in those parts. As a result, the Governor and Company of the Chelsea Waterworks obtained a grant from the king in 1725 to build a reservoir near the walnut trees at the east end of Hyde Park. This would mean that fresh water could be supplied to the town of Kensington, the palace and the new buildings about Oliver's Mount, as well as the northern parts of Westminster. A circular basin of 200 feet in diameter was constructed, with water conveyed to Park Lane and beyond by means of new pipework. In 1731, the York Building Water Company, which had previously supplied the west end of London, folded and the Chelsea Company undertook to provide those parts with water derived from Hyde and St James's Parks, with new pipes laid down specifically for this purpose. At the time of the construction of the basin, a beautiful avenue composed of five rows of walnut trees, with fine gravel walks in the middle, ran parallel to the eastern park wall. This avenue, though already in 1785 described as 'very old and much decayed', continued in existence through the first decade of the nineteenth century. It was cut down in 1811, and the wood used to make stocks for soldiers' muskets, an end scarcely foreseen by those who planted the trees.

On the accession of George I in 1714, Mr Walter Chetwynd, who had been Master of the Buckhounds to Queen Anne, was appointed Chief Ranger of St James's and Hyde Park, as well as Keeper of the Mall. By the time George II succeeded to the throne, Chetwynd had 'resigned' his office to be succeeded by a royal favourite, William, Lord Capel, third Earl of Essex. While George II was improving Kensington Gardens (discussed in detail in Chapter 3), his spouse, Queen Caroline, conceived the idea in 1730 of improving the appearance of Hyde Park by draining the pools and forming the little Westbourne brook into a more extensive stream. Caroline was a woman of considerable taste who took great delight in improving the various Royal Parks. The king, with good humour, refused to look at the plans, believing that she was paying for most of the works out of her own money and little suspecting the aid prime minister Sir Robert Walpole furnished her with from the royal treasury. In order to form the new river, one of the two lodges – styled 'the old lodge' – and part of a grove had to be destroyed. The direction of the whole undertaking was entrusted to Charles Withers Esq., Surveyor General of his Majesty's Woods and Forests, and it was he who gave the Serpentine its present form. At the formation of the Serpentine there appears to have been some intention of erecting a palace in the park. The papers reported, 'Next Monday (5 October, 1730) they begin the Serpentine River and Royal Mansion in Hyde Park. Mr Ripley is to build the house, and Mr Jepherson to make the river, under direction of Charles Withers, Esq.'[7]

200 men were employed to form the new Serpentine, with a dyke thrown across the valley to dam up the Westbourne, and with the soil dug out of this channel a mound was raised at the south-eastern end of Kensington Gardens, on the summit of which was placed a small temple, revolving on a pivot, so as to afford shelter from the winds. Charles Withers died before the works were completed and in 1733 was succeeded by Kimberly. Works progressed quickly, with the Serpentine completed by the end of 1733. Further improvements continued and in September 1736 a basin 300 yards in circumference was made at the end of the Serpentine, 'between the old and the new bridges'. This basin was to receive the waste water from the Serpentine, and an engine was placed under the new bridge to throw the water back into Kensington Gardens.

However, Caroline took many other liberties in relation to Hyde Park. She divested it of just under 300 acres, which were added to Kensington Gardens – at that time entirely reserved for use of the royal family. She contemplated further attacks upon the integrity of Hyde Park; a newspaper article in May 1736 reported,

> A new plan was on Wednesday last presented to her Majesty, for the enlargement of Kensington Gardens, and including the Serpentine, for the pleasure of the royal family. And as we are informed, the said plan will be put in execution as soon as the King's Road in Hyde Park will be completed. 'Tis said there will be several engines erected to make the waters play in emulation of Versailles. A fine pleasure-boat will also be built for the said river, and a little vessel for the exercise and diversion of his Royal Highness the Duke.

In early December the same year, the papers were reporting, 'The Ring in Hyde Park being quite disused by the quality and gentry, we hear that the ground will be taken in for enlarging the Kensington Gardens.'[8] Queen Caroline had very exclusive notions concerning the Royal Parks. At one time she considered taking St James's Park entirely from the public, and

converting it into a noble garden for St James's Palace. Sir Robert Walpole convinced her to change her mind, for when asked what the likely cost would be he told her, 'Only three crowns.'

While Queen Caroline was busying herself with improving the general appearance of the park, George II was engrossed and involved in the construction of a new road to Kensington Palace. This road ran to the south of King William's old Lamp Road. It was originally intended to be railed in, and to have a large ditch on each side. But it was far from successful. From Kensington in 1736, Lord Hervey wrote,

> The road between this place and London has grown so infamously bad, that we live in the same solitude as we would do if cast away on a rock in the middle of the ocean, and all the Londoners tell us there is between them and us a great impassable gulf of mud. There are two ways through the Park, but the new one is so convex, and the old one is so concave , that by this extreme of faults they agree in the common of being, like the high road, impassable.[9]

William, Lord Capel, the third Earl of Essex, continued as keeper until 1739 when he resigned on being appointed Captain of the Yeoman of the Guard. However, his impact on the park had been considerable. That Lord Essex was a strict disciplinarian can be seen from his reaction when a colony of geese from St James's Park was seen in Kensington Gardens. These geese were without respect, it seemed, and scratched holes in the gravel walks and 'otherwise misbehaved themselves'. Essex's response was to order that all the offending geese be shot by the keepers. On his resignation, Thomas, second Viscount Weymouth – who was subsequently created Marquis of Bath and held many high offices, but whose fortune was deeply impaired by gambling – was appointed in his place in 1739.

Cricket was more in fashion at the beginning of the reign of George II than at any other time. The local media reported on many 'grand matches played in various parts of the southern counties for large sums of money'.

Some matches were even played in Hyde Park, as in April 1730, when the players were the Dukes of Devonshire and Richmond, the Earl of Albemarle, Lord James Cavendish and several others.

When the Serpentine was completed, Queen Caroline contemplated even further improvements to the park, which appear not to have been carried out. The old lamp road was to be levelled and made into a fine grass walk for the use of the royal family, with three new gates created at Hyde Park Corner. They were to stand in the form of a crescent, one of them to lead to the new road, the other to the Green Walk and the third to the road leading to Grosvenor Square. In 1737, the papers announced, 'The King's Road in Hyde Park is almost gravelled and finished, and the lamp-posts are fixed up. It will soon be opened and the old road levelled with the Park.'[10] However, it was still causing problems.

> One Sunday night in October, 1739, the Duke of Grafton coming from Kensington, ordered his coachman to drive to Grosvenor Gate, as he intended to make some visits in the neighbourhood of Grosvenor Square. The chariot driving along the King's new road was upset in a large deep pit; the Duke slipt his collarbone, the coachman broke his leg, which was splintered in several places, so that it had to be amputated, and the footman also was severely hurt.[11]

Hyde Park continued to be the favourite place to drive, much as it ever had. The Mall in St James's Park kept up its ancient reputation, and daily attracted thousands; Kensington Gardens also, when the Court was at Richmond or at Windsor, were open to the public on Saturdays, but only

Opposite: The Serpentine, Hyde Park. Attributed to George Sidney Shepherd, 1784–1862. (© Yale Center for British Art, Paul Mellon Collection)

Right: William, 3rd Earl of Essex (*c.* 1697–1748); attributed George Knapton. (© Watford Museum)

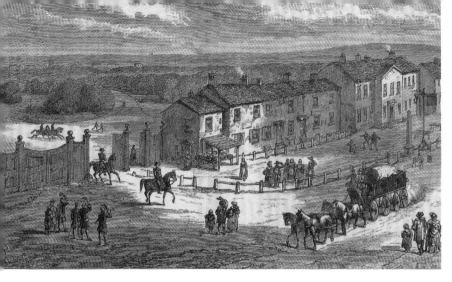

to the higher classes, for such was the sanctity of those courtly precincts that people were only admitted in full dress. In neither of these places, however, were either horses or carriages allowed, and owing to this Hyde Park never lost its attraction – it was very much the people's park. Riding was the fashion among the ladies and it was about this time that the old lamp road, now called Rotten Row or the '*Route de Roi*', became the fashionable ride. The Ring as described in 1736 was now quite disused. When the new road to Kensington was made, it was proposed to level the old one and form it into a grass walk, but this was never carried out. It is likely that the old road became at this time the favourite ride, though it still continued to be used as a drive for carriages as late as the first quarter of the nineteenth century.

Robberies continued to be rife and Walpole himself was a victim of such a crime. In the late evening on 8 November 1749, Walpole was returning home from Holland House when he was stopped from crossing Hyde Park by two highwaymen and robbed of his gold watch and eight guineas. Attempts were made to curb further robberies, with orders issued that in case of future attempts the gate-keepers were to work together and 'at once close the gates, so that the robbers might not be able to escape', as well as further patrols introduced and rewards offered to every person who brought a highwayman to justice. Such incentives made little difference. Hyde Park continued to be an unsafe place. Despite the increased number of hangings at Tyburn, including sixteen perpetrators dispatched at once on 12 March 1752, robberies continued. Duels also flourished in the park. George II himself challenged the King of Prussia to single combat with sword and pistol during one of their disagreements. New streets and squares were arising all around Mayfair

Above: Hyde Park Corner in 1750. (© From Mr Crace's Collection)

Below: *A Family in Hyde Park.* Paul Sandby, 1731–1809. (© Yale Center for British Art, Paul Mellon Collection)

and Marylebone, yet Hyde Park still continued as 'the favourite arena'.

The appearance of the park at this time is described in a poem by Mr W. H. Draper, entitled 'The Morning Walk; or the City Encompassed', written in 1751.

> Behold the Ranger there with gun aslant,
> As just now issuing from his cottage fold,
> With crew Cerberian prowling o'er the plain,
> To guard the harmless deer, and range them in
> Due order set, to their intended use.
> Key he can furnish, but must first receive
> One splendid shilling ere I can indulge
> The pleasing walk, and range the verdant field.

The 'pleasing walk' and 'verdant field' to which the 'one splendid shilling' gained admittance, was an enclosure at the north-west corner of the park previously called Buckdine Hill, the Deer Harbour or the Paddock. This spot was surrounded on three sides by the park wall, Kensington Gardens and the Serpentine. On the fourth side it was divided from the main body of the park by a fence. It was still in existence in the early part of the nineteenth century and 'was the prettiest part of the Park'. Its beauty was enhanced by the small gardens of the keeper's lodge, which stood on the side of the park, the whole being backed by the noble trees of Kensington Gardens. No dogs were allowed in the enclosure, and if any did venture within they were shot by the keepers. Also shot were foxes, which abounded within the park. The minutes of the Board of Green Cloth, in 1798, describe the granting of a pension of £18 to Sarah Gray, in compensation for the loss of her husband, who had been accidentally shot by one of the keepers while they were shooting foxes in Kensington Gardens. Clearly Hyde Park was still very rural in character, as foxes could find a safe lair in such a location and there are descriptions of wild strawberries growing in Hyde Park at this time, which only thrive in their wild state under the shade of forest trees and underwood.

Beneath the row of trees running parallel with the keeper's garden were two springs that were popular at the time – one was used for drinking water and the other for 'bathing weak eyes'. People of fashion used to go to the entrance of the enclosure and would send in their servants with jugs for water, and occasionally their children to actually drink at the spring, the water of which was served by an old woman, who had tables, chairs and glasses for the use of such visitors. The furthest well was generally used by the lower classes of the time for bathing their eyes, the water being described as clear and flowing from the spring 'with great force by an outlet from a small square reservoir'. Walton also comments on grooms training their horses in the park, which was eventually disallowed, and admires the view of the distant Surrey hills with 'Fair Ranelagh's top, Gay peeping in high circumambient form'. As he wanders by the Serpentine, noticing the many fishermen there 'of monstrous bulk, With hungry pike entangled at the hook', he informs us that the Serpentine was at the time a favourite place for drowning illegitimate children. Draper finally arrives at 'Bethesda's sacred pool', with its 'pure healing power'.

> How are Bethesda's wonders here renew'd,
> Nay more, that sacred pool but annual heal'd,
> And then but one: *this* happier, myriads cures,
> The wondrous miracle restor'd to all.
> Hail, salutary spring! Blest source of health!
> Thy vital fire gives vigour to the limbs,
> And lights afresh the brilliant lamp of life!

In 1751, when the Marquis of Bath died, Thomas, the first Earl of Pomfret, was appointed as keeper, but his tenure was a short one as he died in 1753. However, he was responsible for the setting up of globular lamps, instead of the old square ones, along the roads through the park. Reviews continued to

The Drinking Well in Hyde Park, 1802. James Godby, active 1790–1820. (© Yale Center for British Art, Paul Mellon Collection)

be held in the park, as once again England was under threat of invasion, with the French said to be making significant preparations for taking London. One particular review, held on 17 July 1759, was observed by his Majesty in Hyde Park and was 'a nine days' wonder'. On 23 October 1760, George II held his last military review in Hyde Park – just two days before his death.

The number of duels that were occurring in Hyde Park was still considerable, many of which gained notoriety and were reported on at the time. The current ranger, the Earl of Ashburnham, resigned his post

in 1762. As soon as this was known, Henry Fox, the first Lord Holland, wrote to Horace Walpole offering him that office for his nephew George, the third Earl of Orford, and grandson of Sir Robert Walpole. Orford's affairs were in disarray, for both his grandfather and his father had left large debts. Orford eventually accepted the post, but continued to live in the country and hardly acknowledged his new position, retaining the rangership until he died in 1791.

George III was less fond of the pomp and pageantry of war than his predecessors, yet reviews were still held in Hyde Park with military regularity. Hyde Park remained very much the people's park, as defined by the events of the winter of 1767 – one of the coldest that could be remembered. Snow had fallen to such depths across the country that it caused significant chaos, yet in Hyde Park several ladies and gentlemen amused themselves with sleighing 'in a carriage constructed without wheels and drawn with one horse, agreeably to the American fashion, which afforded much entertainment to the spectators.' Crowds were seen skating on the Serpentine daily. In September 1768, *The Public Advertiser* reported of 'deer shooting in Hyde Park, which continued all the evening till dark, when one buck was at last brought down, after having been shot at ten times'. This was the last ever recorded instance of royalty hunting in Hyde Park. A regular visitor to the park at this time was William Pitt, the Earl of Chatham. Dressed in a long riding great-coat descending to his feet, a slouched hat and his hands wrapped in flannel, he used to slowly pace up and down the ride on a small Welsh pony, attended by one servant without livery. Pitt was duly respected as a great statesman and was extremely fond of Hyde Park, and significantly was one of the first to point out the sanitary and health benefits to London of these great open spaces, 'which, with that happy power of metaphor characteristic of his speeches, he was the first to describe as the "lungs of London"'.[12]

During the reign of George III, no fewer than 172 duels were fought in Hyde Park. In three cases both combatants were killed, and there were sixty-

three fatalities overall. In ninety-six cases combatants were wounded, and 188 escaped unscathed. Most of these encounters were generally to do with women, but others were of a more respectable nature. On 16 November 1763, a duel took place between MP John Wilkes and Scottish MP Samuel Martin. Wilkes was at the time well known and quite celebrated, and was a regular visitor to the park in a chariot emblazoned with his arms, which bore the motto 'Arcui meo non confide'. Wilkes was no fan of Scotsmen and disliked Mr Martin in particular, whom he virulently attacked in the *North Briton* for his time spent in office as Secretary to the Treasury.

> The Secretary of a Certain Board, and a very apt tool of a Ministerial persecution, who, with a snout worthy of a Portuguese inquisitor, is hourly looking out for carrion in office, to feed the maw of the insatiable vulture, *imo, etiam in senatum venit, notat et designat unumquemque nostrum*,[13] he marks us, and all our innocent families, for beggary and ruin. Neither the tenderness of age nor the sacredness of sex is spared by the cruel Scot.

After an angry scene in the Commons, Martin replied to Wilkes,

> I desire that you meet me in Hyde Park immediately, with a brace of pistols each, to determine our difference. I shall go to the Ring in Hyde Park, with pistols so concealed that nobody may see them; and I will wait in expectation of you for one hour. As I shall call in my way at your house, to deliver this letter, I propose to go from thence directly to the Ring in Hyde Park; from whence we may proceed, if it be necessary, to any more private place. And I mention that I shall wait an hour in order to give you the full time to meet me. I am, Sir, etc.,
>
> Samuel Martin

Having missed with the first pistols, both antagonists took a second shot, and Martin hit Wilkes 'in full belly'.[14] The bullet ricocheted off his

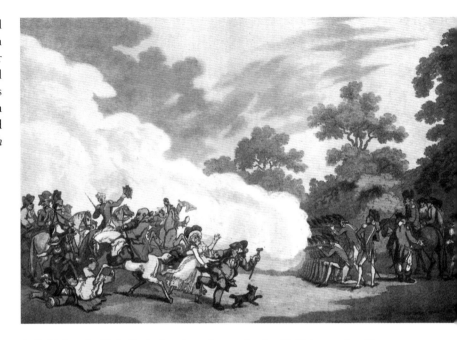

A Field Day in Hyde Park. A coloured aquatint by T. Malton, after Thomas Rowlandson, 1788.

waistcoat buttons – which without doubt saved his life – and ended up in his groin. In this case, both men responded with the 'expected gentlemanliness of the times' and lived to tell the tale. Further duels followed and continued without diminution. In July 1768 two naval officers fought a duel as a result of a disagreement and wounded each other. This was followed in June the following year when a Captain Douglas, a Scot, said some indiscreet words about Wilkes, extending his meaning to anyone who might care to support him, in a coffee-house in

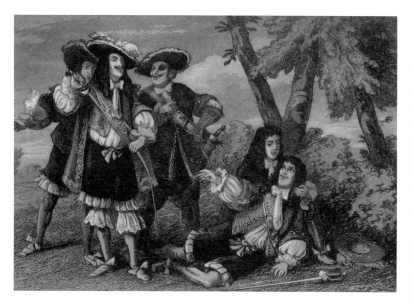

the presence of a Reverend Mr Green. This Mr Green, who had previously been acquitted on a charge of rape at the Old Bailey, immediately jumped up and grabbed Captain Douglas by the nose, offering to lead him by it to Hyde Park. The Scotsman accompanied him to Hyde Park forthwith, without such help, and seconds joined them. They fought with swords, and the parson inflicted a wound on the Scotsman's sword-arm, but as described by the *Gentleman's Magazine*, 'what is the wonderful part of the story, the Captain Douglas, whom the Rev. Mr Green disabled, cannot be found, so that it is supposed this parson, as the humorous sexton of a neighbouring parish says, never fights with a man but he buries him'.

In 1772, playwright Sheridan fought a duel with a Captain Thomas Mathews over the beautiful Miss Linley, to whom Sheridan was secretly married. 'At 6pm on a July evening the parties met near the Ring, but finding too many people about adjourned for a while to the Hercules Pillars, a public-house which stood on the present site of Apsley House at Hyde Park Corner. Returning to the park they still found it too crowded, so they retired to Castle Tavern in Henrietta Street, Covent Garden, and set to it with swords.'[15] Sheridan's account of the duel suggests both parties caused each other appalling damaged, but this may well have been an embellishment of the actual facts.

Although duels and affrays continued in Hyde Park, it was also graced with 'elegant beings'. In 1770, the beau was one such curious character. At the time it was customary for young men of rank to finish their education by 'making the grand tour' on the Continent.

Above: The duel: Captain Disbrowe dying trying to defend his wife's honour from St Paul Parravicin (sheathing sword). Illustration by John Franklin (active 1800–61) for William Harrison Ainsworth's *Old Saint Paul's*, London 1855 (first published 1841). Engraving.

Below: Male and female macaronies: from Jacob Larwood's *Story of the London Parks*.

Most spent their time indulging in the dissipations of the principal capitals of Europe, and returned to England none the better for their experiences gained. Indeed, a number of these young men formed a club in St James's Street, which was called the Savoir Vivre Club. Dinners here were frequent, and with foreign dainties served at many of them; macaroni formed a standard dish. Before long the name of this Italian food, then a novelty in England, was bestowed upon the 'exquisites' who enjoyed it. Consequently the term *Macaronies* became commonplace, and under their continued ascendancy fashion ran wild into bad taste and exaggeration. *Macaronies* seemed to enjoy wearing their hair in a very high foretop, with long side curls and an enormous club or *chignon* behind, which rested on the back of the neck. On the top of their head they wore a very small cocked hat, with gold buttons and tassels on each side. The coat, waistcoat and breeches were all equally short and tight fitting; the latter item was often striped silk with large bunches of ribbon at the knee. The cane, often used to lift the hat from the head, was equally as ostentatious as the rest of the costume, of great length and decorated with a large number of tassels. The ladies' attire was just as outrageous: the head decorated with enormous masses of hair, frequently surmounted by plumes of feathers and by bunches of flowers. Hoops were discarded and the gown trailed upon the ground. The *Macaronie* phase lasted about five years, from 1770 to 1775, with duelling at its peak in the park. Robberies were as frequent as ever, despite the introductions of lamps, guards, patrols and periodical hangings at Tyburn. Additional guards were posted in the park in September 1772, 'to prevent robberies, as several attendants of the royal family, returning after nightfall from London to Kensington, had been attacked by footpads'. One account is especially bold. One Sunday evening in July 1774, two men 'of genteel appearance' struck up an acquaintance with two ladies in Kensington Gardens, as was the fashion of the day, and promenaded with them several times up and down the broad walk. At last the ladies talked of retiring, and the gallant fellows at once requested to be allowed the honour of walking them home. As evening was approaching the ladies gladly accepted and the four walked together through Hyde Park. Night in the meantime had completely set in, but both young ladies were confident in the 'gallantry of their cavaliers'. They were soon to discover they were woefully mistaken, for as they approached Grosvenor Gate the two gentlemen 'at once presented pistols to the ladies, and instead of begging their heart and hand, as perhaps they had expected after their romantic walk, coolly demanded their watches, money, and jewels, and took them without the least compunction'.[16]

George III was a frequent visitor to Hyde Park, regularly taking exercise here. His subjects would see him almost daily, sometimes on horseback, but more often in a chariot driven by four horses. He was certainly a man of frugal habits and an early riser, and dressed like an old English farmer might be seen trotting down the ride in the park by seven in the morning, returning home again between nine and ten. For a while, reviews became less frequent in Hyde Park as they were now often held on Blackheath, Ashford Common, Hounslow Heath, Sydenham and Wimbledon Commons. In February 1778, Lord Orford was succeeded in the office of 'Ranger of the Parks' by General Charles Fitzroy. He only remained in office for two years, but during his time the military camps returned to the park. The Gordon Riots had begun on 2 June 1780 and within days Hyde Park became an armed camp again, with 3,823 troops stationed there. George III was seen often among the troops, sometimes on horseback but more generally on foot. Sentries posted at the gate were instructed to keep out the working classes. This discrimination, on top of the unpopularity of these manoeuvres, caused anger among the population of London. George himself felt it expedient at the time to assure Parliament in a speech from the throne that he had no design on the nation's liberty. In July, Walpole wrote, 'Dissatisfaction grows

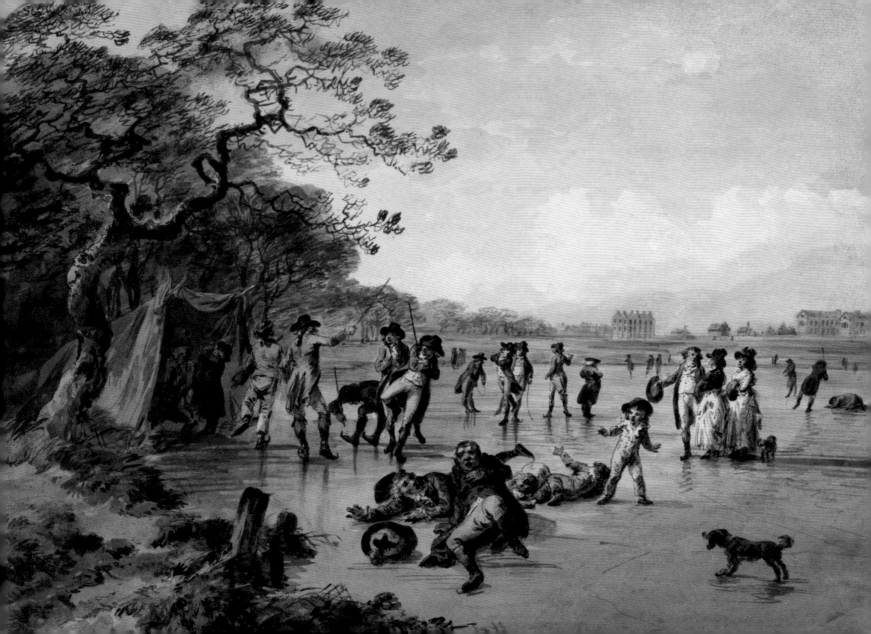

again on the continuance of the camps.' It was this dissatisfaction that eventually led to the break-up of the camp in Hyde Park on 10 August.

The second freezing winter of George's reign was in 1784, when the popular Prince of Wales was among the spectators of the skating in the park, sporting a fur pelisse said to have cost £800 and a black muff from Paris to warm his hands, setting a new fashion among both sexes. The defeat of England at the hands of America, France and Spain heralded a new era in English national manners, with the end of the effeminate, quarrelsome, self-promoting and grotesque nature of the *Macaronies*. Women were now revolting against the tyrannies of extravagance and counter-extravagance, and obedience to masculine style. In this cold winter, ankles were seen on the Serpentine, as well as the first dog-skin shoes. Despite his father granting him £50,000 a year on his coming of age, the Prince of Wales had already managed to incur debts totalling £161,660. In 1787 the Prince, having sold most of his horses and much of his furniture in Carlton House, appeared on horseback in Hyde Park, according to *The Times*, 'dressed quite like a private gentleman, and attended by only one servant', thus setting a new fashion. Riding and driving along Rotten Row – first referred to as such in 1781 – were now the fashion in Hyde Park, although it took a while for older park visitors to get used to the simplification of style in the way of carriages. 'A whole gamut had to be gone through before this, from gigs lined with looking-glass, phaetons we should call nowadays, "fillteted", curricles followed by grooms, more gigs giving rise to tilburies and whiskies. Curiously the horses were seldom thoroughbred: long-tailed blacks and Cleveland bays prevailed, and a speed of six miles an hour was considered great.'[17] 'The porcelain clay of human nature' was also smitten with the new equine mania on Rotten Row, and no lady was considered of the *ton* (of the highest style) unless she could drive her 'team' and 'keep the cattle up to their work' with consummate skill. Lady Lade, wife of 'Sir Jacky Jehu', and Mrs Hodges were among the most popular attractions on Rotten Row. 'They rode on Thursday during a severe stag-hunt. But Mrs Hodges

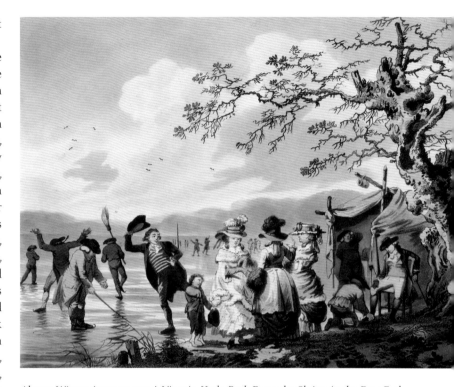

Above: *Winter Amusement: A View in Hyde Park From the Sluice At the East End*, 1787. Print made by James Tookey, active 1787–1805. (© Yale Center for British Art, Paul Mellon Collection)

Opposite: Skating in Hyde Park, 1785. Julius Caesar Ibbetson, 1759–1817. (© Yale Center for British Art, Paul Mellon Collection)

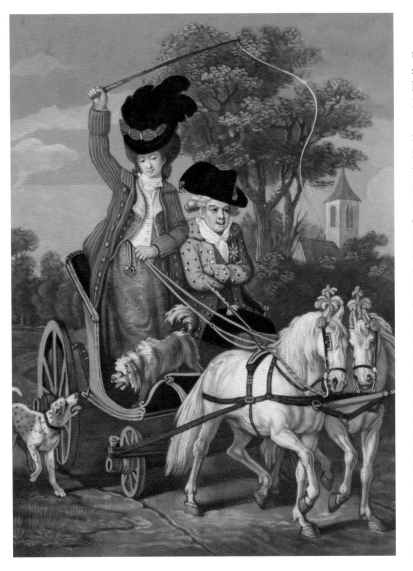

not only out-leaped Lady Lade, but every gentleman in the field. Nothing stopped her: she flew over a five-barr'd gate with as much agility as she leapt into a lover's arms. It was remarked she had all the properties of a Dian – except her chastity.'

With the war in the Americas now at an end, the country once more returned into a more peaceful period. The papers were reporting, 'Almost innumerable were the persons who took the dust in Hyde Park.' In May 1783, the Rangership was conferred upon John, fourth Earl of Sandwich, who while in post was nicknamed 'Jemmy Twitcher' and was deeply unpopular. The Mall in St James's Park was not being properly 'swept and garnished' and the state of Hyde Park was also deemed unsatisfactory, owing to the inefficiency of the police. Robberies were still occurring daily. *The Public Advertiser* reported on 23 August 1783, 'In the evening all is depredation, robbery, and the filthiest debauchery. People are robbed and stripped as they pass, and the robbers and their trulls hardly ever quit the ground.' Lord Sandwich lasted but a year, and the office was swiftly returned to Lord Orford, who continued in the post until his death in 1791. The war with America, France and Spain had again given a new impulse to the rage of duelling, and on occasion boxing matches were also held in the park. In February 1785, a large number of people gathered at a battle fought between Ben Green of Carnaby Market, nicknamed Tantrabolus, and Stephen Myers of the Adelphi, commonly called Chitty. The conflict lasted nine and a half minutes, and victory declared for Myers, who was only five feet and one inch tall. In June of the same year another match was held, but the 'bruisers' never appeared. A large crowd had gathered with twenty to thirty seats taken on the branch of a large tree, which gave way under the weight. Several spectators were badly bruised, while three ended up in hospital with broken legs. Sundays continued to be the fashionable day for Hyde Park, with the usual mixture of dukes and

Kitty Coaxer Driving Dupe, Towards Rotten Row, 1779. Unknown artist, eighteenth century. (© Yale Center for British Art, Paul Mellon Collection)

duchesses, countesses, generals, maids-of-honour, country parsons, and 'tag-rag and bobtails' often to be seen taking air there.

In 1791 Lord William Wyndham Grenville succeeded to the keepership of the park. His tenure was short-lived, lasting only two years before he resigned in 1793. He was succeeded by George Henry, Earl of Euston. One of his first improvements was the opening of an additional door for foot passengers at Hyde Park Corner. He also opened another gate between the park and Kensington Gardens, where the crush used to be considerable, especially on Sundays. It was during this period that the subject of building a palace in Hyde Park was once again broached. This time it was

> [Sir John] Soane, who, in the gay morning of a youthful fancy, full of the wonders he had seen in Italy, and inspired by the wild imagination of an enthusiastic mind, proposed, without regard to expense or limit, to erect a royal habitation in the Park. It was to consist of a palace with a series of magnificent mansions, the sale of which was calculated to defray all the expenses of the erection: the whole of the buildings was to extend from Knightsbridge to Bayswater, and to be relieved by occasional breaks.

Previous plans had been drawn up as early as 1731 and later by John Gwynne in 1766. In 1779 a further proposal was being debated in one of the papers. The last proposal of this kind was in 1825, when a design was published for a magnificent royal palace to be erected near Stanhope Gate. Thankfully, none of these plans ever came to maturity.

In the summer of 1793, the road, the ride and the promenade in Hyde Park were 'daily full of the best company', and the *Morning Post* declared that 'there never was a fuller season.' With it came significant complaints of horses crossing the walks, kicking up clouds of dust on both sides. The once admired lawn next to the Serpentine 'may now very properly be called Rotten Row, and from a beauteous scene is now a dusty road'. The winter of 1795 was again severe, with ten weeks of frost and the

A Military Encampment in Hyde Park, 1785. James Malton, 1761–1803. (© Yale Center for British Art, Paul Mellon Collection)

Serpentine frozen several inches thick. The usual conflux of *beau monde* congregated here, with ladies dressed in velvet 'from the bonnet down to the shoe'. More frequent visitors to the park were the Prince of Wales, who was often in the company of Mrs Fitzherbert – who was secretly married to him in 1790 and lived with him for five years as his wife. During the season the prince used to drive almost daily with her to the park. By 1795, Mrs Fitzherbert no longer visited with her husband, having been

Top: *Hyde Park Corner.* Thomas Rowlandson, 1756–1827. (© Yale Center for British Art, Paul Mellon Collection)

Middle: *Sketch of a Half-Facade for a Royal Palace, Hyde Park, London,* 1779. Sir John Soane, 1753–1837. (© Yale Center for British Art, Paul Mellon Collection)

Bottom: *Design for Hyde Park and St. James's Park Entrance,* 1826. Sir John Soane, 1753–1837. (© Yale Center for British Art, Paul Mellon Collection)

Opposite: *View of the Serpentine River, Hyde Park, Looking from Kensington Gardens,* 1796. Francis Jukes, 1747–1812. (© Yale Center for British Art, Paul Mellon Collection)

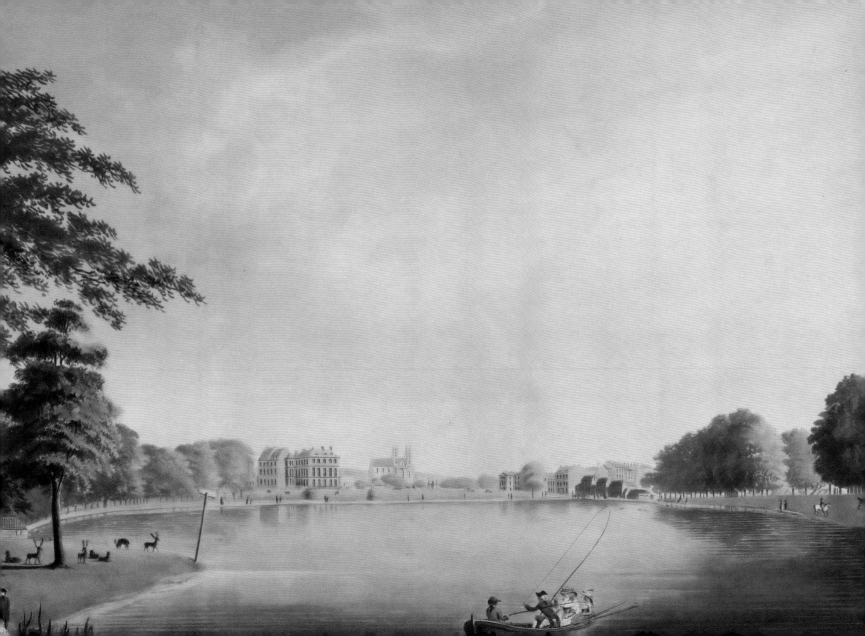

An Airing in Hyde Park, 1796. Thomas Gaugain, 1748–1812. (© Yale Center for British Art, Paul Mellon Collection)

pensioned off with £3,000 a year. On 15 April of the same year, Princess Caroline of Brunswick was seen for the first time – without her new royal husband. She drove in a coach attended by Lady Cholmondley. Described by *The Times*, 'She is very fair, and nature has painted her cheeks with a delicate red. She comes in the season when all nature is blooming and benevolent like her, to add variety to the lilies and roses of the Spring.' Within the year there were rumours of a separation, but the princess remained a regular visitor to the park.

A kilted regiment was for the first time reviewed in the park in 1796.

The king met the regiment at the parade in St James's Park, and rode at the head of the troops towards Hyde Park. The novelty of the uniform had attracted an enormous crowd with 'all the beauty and fashion of the West end'. The French Revolution and the threat to invade England made reviews again the order of the day in Hyde Park. The end of the eighteenth century was bitterly cold, with skating again on the Serpentine, the usual host of fashionable skaters whirling along its surface. It was also the time of George Bryan Brummel – or Beau Brummel – who was now considered 'the glass of fashion, and the mould of form, The observed of all observers', and who brought masculine attire to its peak in Hyde Park.

The advent of the nineteenth century was cold and wintry, but the weather did not seem to deter the 'ultra-beauties' according to *The Times*. Hyde Park was given over almost completely to manoeuvres, with 'seven tonnes of powder a week consumed in practices'. Such activities so frightened the deer on Buck Hill in the north-west corner of the park that they stampeded and swam the Serpentine. By 1814, the centenary of the accession of George I, display and jollification was the order of the day. Napoleon had fallen and Louis XVIII passed through the park on 20 April with an imposing procession on his way from Hartwell in Buckinghamshire, to Versailles, the Prince Regent having met him on the way. But this procession did not compare with the Rotten Row cavalcade of Allied Monarchs and generals, which took place on 12 June. At 11.30 a.m. a royal salute of twenty-one guns announced the entry of the Allied Monarchs at the Hyde Park Corner Gate, when the Prince Regent entered with his hat off, bowing to the right and left, where the King of Prussia rode beside him. Nearly 300 notable Allied persons followed, the greatest ovations being accorded to Platoff, Hetman of the Don Cossacks and to General Blücher, who was so frightened that he jumped off his horse and escaped into Kensington Gardens.

On 1 August there was a day of great national rejoicing. In Hyde Park

there was a fair and for the first time the Serpentine was used for national purposes, with a sea-battle taking place on its waters. These displays were not especially successful, in contrast to the fair which was held along the whole of the south side of the park. It was intended to last for twelve days, but with such excitement Lord Sidmouth, the Home Secretary, ordered it to be closed down at the end of the week. In the latter days of George III's reign, Hyde Park was bleak and comfortless. The military precautions had impacted heavily on the park and had meant the uprooting of many trees, including the fine avenue of walnuts which fringed the drive along the Park Lane side, felled in 1811 to make musket-stocks. Byron described the park during this period as

> A vegetable puncheon
> Call'd Park, where there is neither fruit nor flower
> Enough to gratify a bee's slight munching:
> But, after all, it was the only 'bower'
> [In Moore's phrase] where the fashionable fair
> Could form a slight acquaintance with fresh air.

On 19 July 1821, George IV was crowned king. For the first time in history, coronation celebrations were held in Hyde Park. The south side of the park was again used for festivities, the Serpentine used for a boat race, with tents and marquees erected at the Ring 'where democracy regaled itself heartily with food and drink'. All social classes were represented at the rejoicings, while two well-upholstered elephants, each mounted by a female 'Eastern Slave', represented Britain's now far-flung Empire. By the evening, with the expectation of a generous fireworks display, the park gates had to be closed to stem the increasing numbers of people flooding in. But they were not to be outdone; many brought ladders and 'rushed them to the palings on the north side of the Park and London swarmed over them, at a halfpenny toll each to the

His Majesty Reviewing the Volunteer Corps Assembled in Hyde Park, 1801. Richard Earlom, 1743–1822. (© Yale Center for British Art, Paul Mellon Collection)

ladder-proprietors'. However, this method was too slow for some, and the railings were simply ripped out to gain access.

A year later Hyde Park staged a very different scene, on the occasion of the death of George IV's unhappy queen. Caroline had enjoyed great popularity and sympathy from the public, due to the treatment she had received from the king. She died on 7 August 1821 at Brandenburg House, Hammersmith, having expressed the wish that her remains be buried with her ancestors at Brunswick. On the 14th the removal to Harwich for interment took place. In order to avoid public demonstrations, the

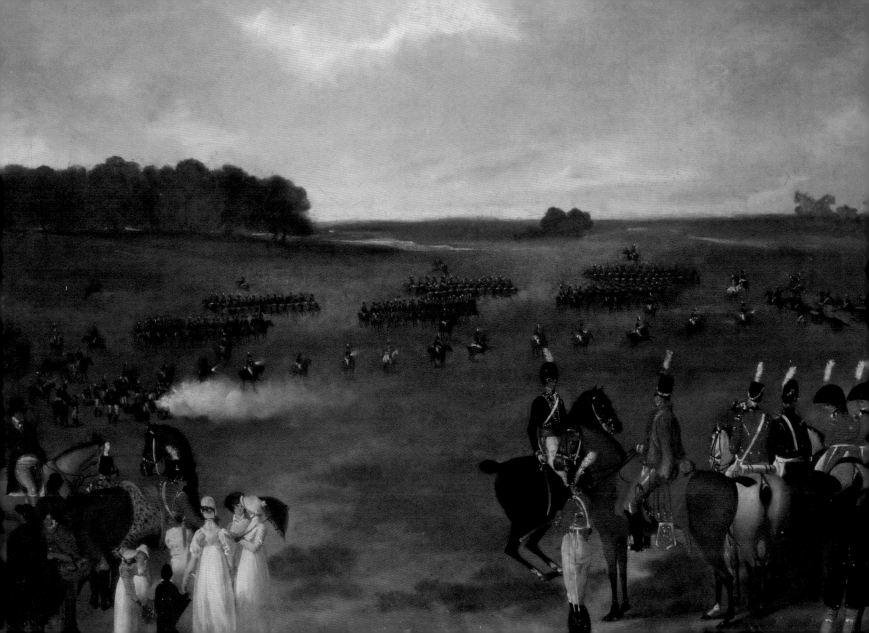

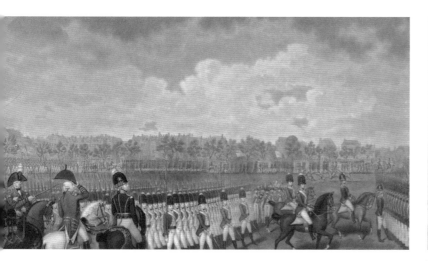

Above: *His Majesty Reviewing the Armed Associations the Fourth of June in Hyde Park*. Joseph Collyer, 1748–1827. (© Yale Center for British Art, Paul Mellon Collection)

Above right: *Trees in Hyde Park*, London, 1800. Thomas Girtin, 1775–1802. (© Yale Center for British Art, Paul Mellon Collection)

Right: *Scene on the Serpentine, Hyde Park on the Night of the Grand Jubilee*, 1 August, 1814. Unknown artist. (© Yale Center for British Art, Paul Mellon Collection)

Opposite: *A Review of the London Volunteer Cavalry and Flying Artillery in Hyde Park in 1804*. Unknown artist. (© Yale Center for British Art, Paul Mellon Collection)

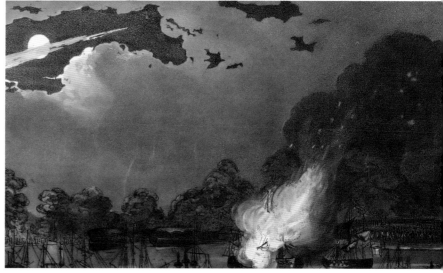

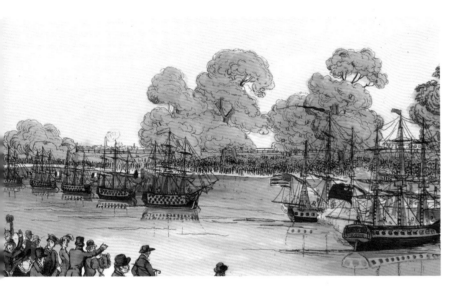

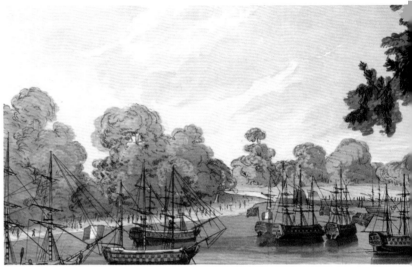

Above: *View in Hyde Park, with the Fleet at Anchor on the Serpentine River*, 12 August 1814. Unknown artist. (© Yale Center for British Art, Paul Mellon Collection)

Above left: *The Action between the British and American Frigates on the Serpentine*, Hyde Park, 1 August 1814. Unknown artist. (© Yale Center for British Art, Paul Mellon Collection)

Left: *Fashionables of 1816 Taking the Air in Hyde Park!*, 1816, unknown artist. (© Yale Center for British Art, Paul Mellon Collection)

Opposite: *Hyde Park*. John Martin, 1815. (© Yale Center for British Art, Paul Mellon Collection)

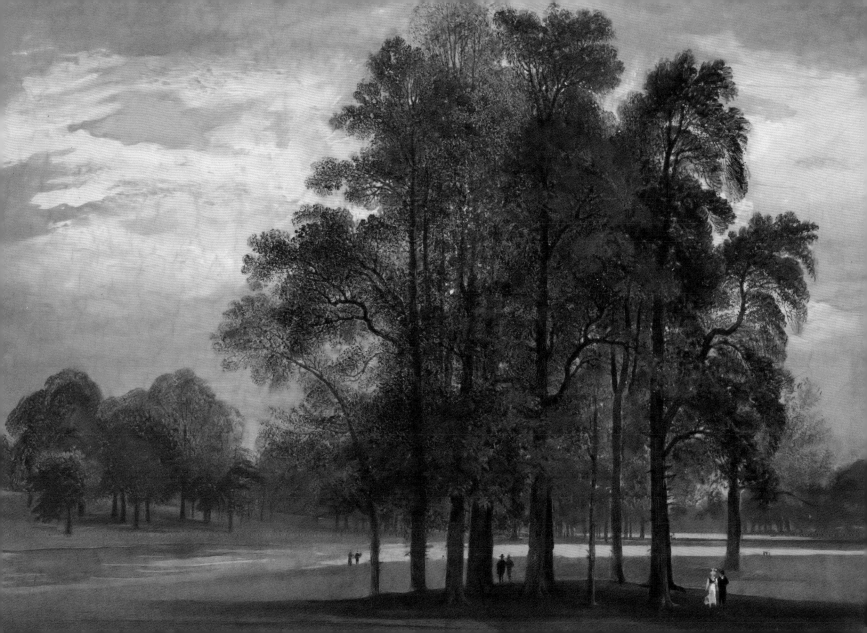

authorities had decided that the hearse, with its mile procession, should not be taken through the City. But the public interjected. They barricaded Church Street, Kensington, forcing the cortège to proceed after an hour's delay in the direction of Piccadilly. But this too was obstructed and Life Guards had to storm the barricades. The Guards had to force a way into Hyde Park through the Hyde Park Gate, where a battle raged. Four people were killed and several wounded on both sides, with the procession eventually forced to proceed through the City headed by the Lord Mayor.

In 1822, a new introduction to Hyde Park caused great controversy. The statue of Achilles was erected. Although discussed later, the 'Ladies of England' felt that no finer tribute could be paid to the Duke of Wellington than to erect such a statue in Hyde Park. Weighing thirty-five tons and cast out of twelve 24-pounder long guns captured from the French at Salamanca, Vittoria, Toulouse and Waterloo, it was not popular. 'The English public, never having seen a naked statue before, abandoned Wellington Drive, retreating before his "Disgrace" into Rotten Row and the Ladies Mile.'[18] During George IV's reign many improvements were made to the park. There was a great debate at the start of the nineteenth century about building an entirely new royal palace, but when the new king ascended to the throne, the plan was abandoned. George IV was sixty years old, overweight and in poor health. Having felt very much at home at The Queen's House during his childhood, the king wanted the existing house to be transformed into his palace. The king placed John Nash, Official Architect to the Office of Woods and Forests, in charge of all the work. During the last five years of George IV's life, Nash enlarged Buckingham House into the imposing U-shaped building that was to become Buckingham Palace. However, the building of Buckingham Palace had many repercussions, the most immediate being the improvement and architectural furnishing of Hyde Park. Here the Office of Woods and Forests was in charge, under the guidance of Lord Goderich; their architect was a very young man called Decimus Burton. A protégé of Nash, he had been working with him at Regent's Park when he had designed his father's Regent's Park villa, 'the

Holme', and when he was only twenty-one years old Cornwall Terrace was being built from his designs. At twenty-five he was commissioned to design the two works by which he will always be remembered: the screen and arch at Hyde Park Corner. These handsome ornaments, together with the smaller gates and lodges, were decided upon by an informal committee of peers and commoners from whom Burton received his instructions. The intent was to bring Hyde Park within the monumental orbit of the new palace. First Burton provided a plan for the drives and pathways. Then he built the lodge at Grosvenor Gate followed by the two most original, semi-Italian lodges at Stanhope Gate. Cumberland Lodge followed, along with the lodge at Hyde Park Corner and finally the Ionic screen and the Pimlico arch. The screen and the arch belong to each other; the arch was originally on the same axis as the screen, so that the graceful Ionic of the latter made a formal preface to the rich Corinthian mass of the arch. The whole point of the composition was to make a monumental crossing from Hyde Park to the Green Park, the road through the arch sweeping immediately to the left, down Constitution Hill and into the forecourt of the palace. In 1888, the arch was rebuilt normal to the axis of Constitution Hill, and the relation between the two buildings was destroyed. Both screen and arch are effective designs and show how much Burton was able to derive from the education supplied by his not-very-scholarly father and the drawing school of George Maddox. The screen itself may have been inspired by Holland's Ionic screen at Carlton House, which was demolished about the same time. In that example, the screen served to protect the open side of a palace forecourt, and a vestige of that idea remains in the Burton design if one considers it as a preface to the great arch, which was, in its original position, the outer gateway of Buckingham Palace. The central entry in the screen is a 'Palais Royal' idea, but it was Burton's notion to crown it with an attic ornamented by John Henning's imitation of the Pan-Athenaic frieze.[19]

The 'Green Park Arch' was strictly Roman in contrast to the more conservative Marble Arch. Burton's arch was never finished, and in 1846

Above: *View of a Triumphal Arch Proposed to Be Erected At Hyde Park Corner Commemorative of the Victory ... King George III*, 1813. Robert Havell, 1769–1832. (© Yale Center for British Art, Paul Mellon Collection)

Left: *Achilles Statue, Hyde Park, London*. Peter DeWint, 1784–1849. (© Yale Center for British Art, Paul Mellon Collection)

Right: *Statue of Achilles in Hyde Park*, 1827. Print made by Samuel Freeman, 1773–1857. (© Yale Center for British Art, Paul Mellon Collection)

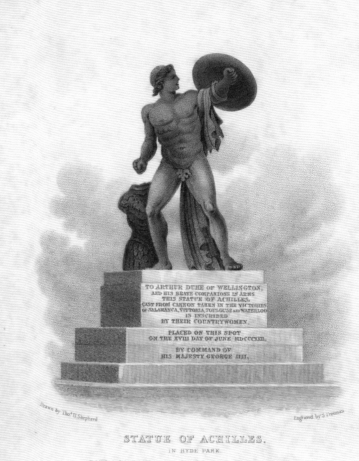

TO ARTHUR DUKE OF WELLINGTON,
AND HIS BRAVE COMPANIONS IN ARMS
THIS STATUE OF ACHILLES,
CAST FROM CANNON TAKEN IN THE VICTORIES
OF SALAMANCA, VITTORIA, TOULOUSE AND WATERLOO
IS INSCRIBED
BY THEIR COUNTRYWOMEN.

PLACED ON THIS SPOT
ON THE XVIII DAY OF JUNE MDCCCXXII.

BY COMMAND OF
HIS MAJESTY GEORGE IIII.

Drawn by Thos H Shepherd Engraved by S Freeman

STATUE OF ACHILLES.
IN HYDE PARK.

Published July 7, 1827 by Jones & Co 3 Acton Place, Kingsland Road, London.

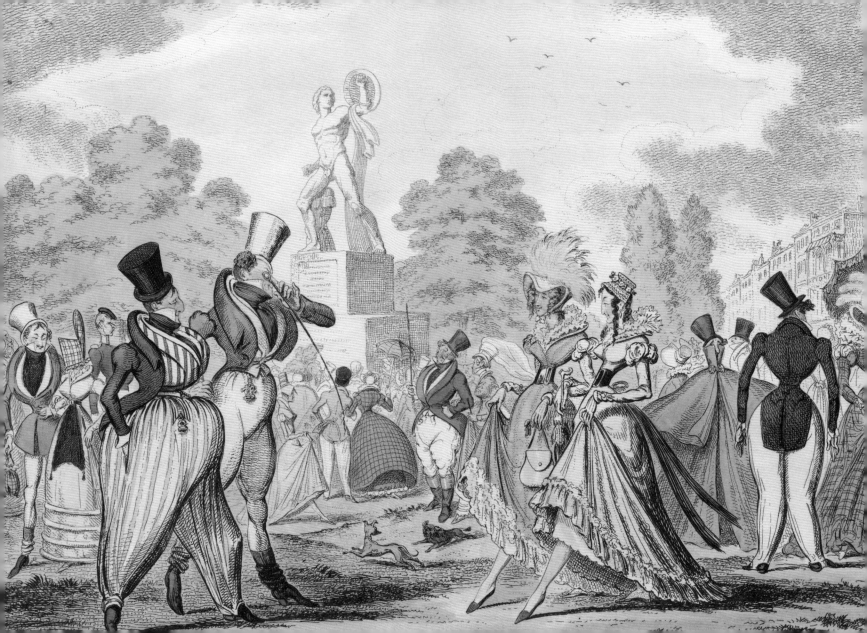

it suffered the fate of being made the pedestal for a very bad equestrian statue of Wellington. Due to traffic congestion, in 1883 the now Wellington Arch was dismantled and re-built a short distance away on its present site at the top of Constitution Hill. Wellington's equestrian statue was, due to its controversial size, removed from the top of the arch and taken to Round Hill, near the military town of Aldershot in Surrey. In 1912 *The Quadriga*, commissioned by Edward VII, was placed on top. Depicting the angel of peace descending on the chariot of war, it is the largest bronze sculpture in Europe, 'curiously distorting its character and generalising its neat Georgian classicism into Edwardian Baroque'.[20]

Burton's other work for the Woods and Forests included the Guards' Magazine House in Hyde Park, as well as the Parliamentary Stables in Storey's Gate, which caused him significant grief. For this building he was made to give a lavish architectural disguise in deference to the sensibilities of the Dean and Chapter of Westminster – a concession which he had to explain before a somewhat critical Select Committee. These expensive stables have long since disappeared. One other significant introduction to the park at this time was George Rennie's bridge of five segmental arches over the Serpentine, a magnificent piece of masonry construction which owes its existence to George IV. In the same period, Charles II's brick wall was pulled down, with new iron railings erected in its place. The park was changing significantly, and yet it remained, as ever, the people's park.

The coronation of the Duke of Clarence as King William IV in 1830 occasioned fewer festivities in Hyde Park than that of his brother. There was only a display of fireworks, at which six people were injured seriously enough to be hospitalised. King William and Queen Adelaide used only to drive around the Serpentine. Their reign is chiefly marked for the passing of the Reform Bill, which laid the foundations of political democracy in England.

Opposite: *Monstrosities of 1822 – Pt. 5*, 1835. Print made by George Cruikshank, 1792–1878. (© Yale Center for British Art, Paul Mellon Collection)

The Duke of Wellington was not one of those who approved of reform, and as a result on 22 April 1831 a crowd of supporters of the Bill made a rush at Apsley House and hurled volleys of stones at its windows, breaking all of them and damaging several pictures in the gallery inside. From 1855 to 1866, Hyde Park was to witness many turbulent demonstrations. The first of these was in July 1855 against Lord Grosvenor's 'Sunday Trading Bill', when over 150,000 people assembled and various scenes of disturbance took place. Riots occurred frequently, culminating in the Reform League riot in July 1866, when the railings between Marble Arch and Grosvenor Gate 'were entirely demolished, and the flower beds were ruined.' This is discussed later when oratory is introduced to Hyde Park.

On 20 June 1837, the eighteen-year-old Princess Alexandrina Victoria was visited at her home in Kensington Palace, and was given the news that would change her life. At 11 a.m. the same day, Queen Victoria held her first council at Kensington Palace. The new queen had spent her childhood days with her mother at Kensington Palace and played regularly in the gardens. It was here that she met her first cousin, the Saxe-Coburg prince who was to become her consort. On 28 June 1838, Victoria was crowned and a great coronation fair was held in Hyde Park, between the Serpentine and Park Lane. The booths that were erected provided a riot of amusement and included exhibitions of fat boys, living skeletons, Irish giants and Welsh dwarfs, children with two heads and animals with none. The *Morning Advertiser* described it in detail;

The delightful locality of the fair, the bright sunbeams playing upon the many coloured tents, the joyous laughter of the people, untouched by debauchery, and unseduced by the gross pleasures of the appetite; the gay dresses of the women, all in their best, joined in making the scene one which must live in the recollection of those who witnessed it. All appeared to remember that this was the day of the Coronation of a Queen, so youthful, so beautiful, so pure, and all appeared to be determined that no act of insubordination, or of

The Old Magazine Hyde Park

Serpentine, Hyde Park. London

Above: *The Gunpowder Magazine, Hyde Park*, 1793. Paul Sandby, 1731–1809. (© Yale Center for British Art, Paul Mellon Collection)

Above left: *The Old Magazine, Hyde Park*, 1807. James Peller Malcolm, 1767–1815. Later remodelled by Decimus Burton. (© Yale Center for British Art, Paul Mellon Collection)

Left: George Rennie's bridge of five segmental arches over the Serpentine.

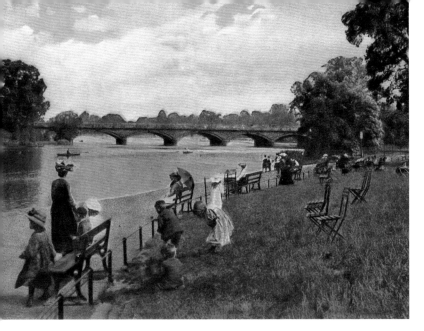

Serpentine Bridge, 1825–28, built by Messrs Jollife and Bankes.

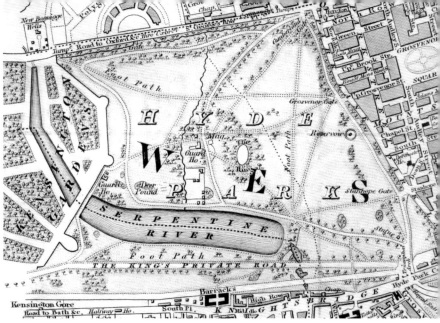

Hyde Park section of 'Improved map of London for 1833, from Actual Survey. Engraved by W. Schmollinger, 27 Goswell Terrace'.

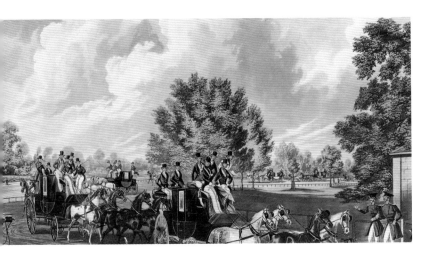

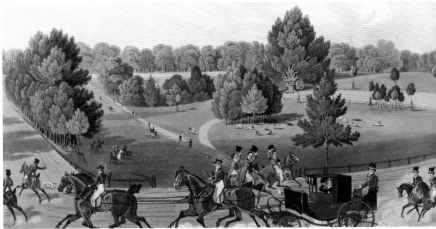

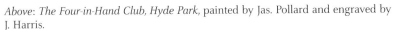

Above: *The Four-in-Hand Club, Hyde Park*, painted by Jas. Pollard and engraved by J. Harris.

Above right: *Coaching: His Majesty King George IV. Travelling – View Hyde Park, 1821*. Matthew Dubourg, 1786–1838. (© Yale Center for British Art, Paul Mellon Collection)

Right: *Police Waiting for the Reform Meeting. Illustrated London News*, May 1867.

Opposite: *William Massey-Stanley Driving His Cabriolet in Hyde Park*, 1833. John Ferneley, 1782–1860. (© Yale Center for British Art, Paul Mellon Collection)

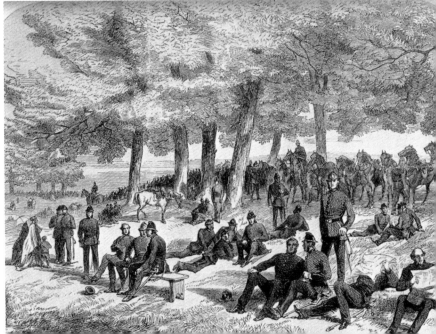

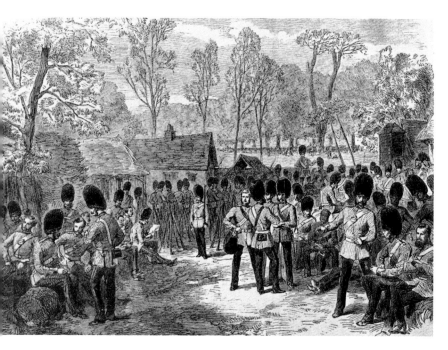

Grenadier Guards Waiting for the Reform Meeting. A contemporary engraving from the *Illustrated London News*, 18 May 1867.

disorder on their part should sully the bright opening of a reign so hopeful, and from which so much happiness is to be expected.

The queen was driven to the fair in the park and was given a great ovation on her arrival, with the fair lasting four whole days. A few days later, on 9 July, there was a significant demonstration in Hyde Park, which did much to seal the ongoing friendship between England and her traditional enemy across the English Channel. In the last review to be held for twenty-two years in Hyde Park, the new queen reviewed 5,000 hand-picked troops in the presence of Marshal Soult and the Duc de Nemours.

The queen married Prince Albert and ultimately moved to Buckingham Palace, but it was the attempted murderous attack by Edward Oxford on 10 June 1840 at Constitution Hill that endeared her to the British people. The day after the attempt, Victoria and Albert drove in Hyde Park amid public cheers. They would drive every evening in Hyde Park between five and seven 'without pomp and drawn swords'. Rotten Row became a place of great etiquette, where it was now taboo to be vulgar, drunk or even to smoke, as 'it offended the new frail sex'. 'Ladies' had come into existence and books on etiquette were the vogue. The 'improving forties' was a decade of attitudes both physical and moral, with the 'Lower Orders' looking on over the railings. One of the regulars to the park was 'that old rebel', as the queen had called him, the Duke of Wellington. Schlesinger describes him;

an old man with his horse walking at a slow pace, his low hat pushed back that the white hair on his temples may have the benefit of the breeze. His head bent forward, the bridle dangling in a hand weak with age, the splendour of the eyes half-dimmed, his cheeks sunken, wrinkles round the mouth, and on his forehead, his aquiline nose bony and protruding; who does not know him? His horse walks gently on the sand; everyone takes off his hat, the young horse-women get out of his way; and the Duke smiles to right and to left. Few persons can boast so happy a youth as this old man's age.

The idea of introducing flowers into Hyde Park began in about 1860, and the long rows of beds between Stanhope Gate and Marble Arch were made about this time, when Mr Cowper Temple was First Commissioner of Works. They were made when 'bedding out' was at the height of its fashion, when the idea was to have either large, glaring patches of bright flowers as dazzling as possible, or minute and intricate patterns carried

out in carpet bedding. By the end of the nineteenth century, much of this stiffness and crudeness was replaced by planting that showed a variety of colours and plant species. The original place where all the plants were raised was a series of greenhouses and frames in front of Kensington Palace – the erection of which completely destroyed the design of the old garden. In 1903, three acres in the centre of Hyde Park were taken to form fresh nurseries and remain well hidden within the park. There were storehouses for bulbs and nurseries where masses of wall-flowers, delphiniums and all the hardier bedding plants and those for herbaceous borders were grown. Mrs Evelyn Cecil, writing in 1907, quantifies the areas of flower beds and borders in the main Royal Parks.[21]

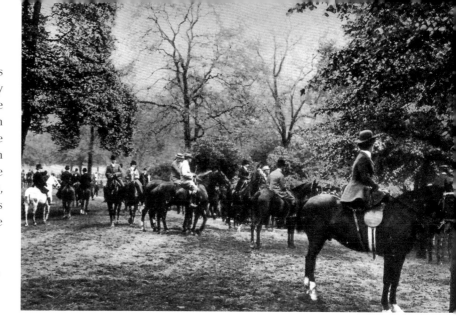

	Area of flower beds (square yards)	Area of flower borders (square Yards)
Hyde Park	1742	2975
Kensington Gardens	345	3564
St James's Park	30	2642
Queen Victoria Memorial in front of Buckingham Palace	1270	
TOTAL	3687	9181

However, it was the Great Exhibition of 1851 that became one of the most significant events in the history of Hyde Park. Various sites, such as Battersea Park, Regent's Park, Somerset House and Leicester Square, were suggested, but the ultimate location chosen was Hyde Park, on the space

Above: The morning ride on Rotten Row.

Below: Promenading on the Row.

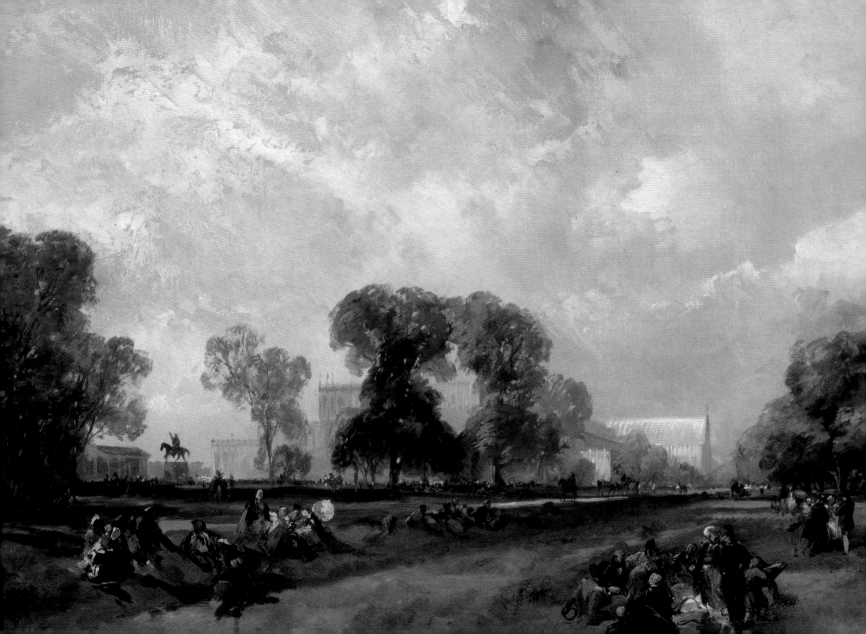

between Rotten Row and Knightsbridge Barracks. Plans were submitted in competition, and although 245 were sent in, not one satisfied the committee. So, assisted by three well-known architects, they evolved a plan of their own. This was to be carried out in brick; the labour of removing it after the Exhibition would have been stupendous. It was when this plan was under consideration that Joseph Paxton showed his idea for the building of iron and glass so well known as the Crystal Palace. It was 1,851 feet long and 408 feet wide, with a projection on the north of 936 by 48 feet, with the building covering about nineteen acres. However, one stipulation was required before the design was accepted: that three great elm trees growing on the site should not be removed, but rather included in the building. Alterations were made and the trees encased within the Crystal Palace. Smaller trees were cut down, which led to some ridicule in *Punch*;

> Albert! Spare those trees,
> Mind where you fix your show;
> For mercy's sake, don't, please,
> Go spoiling Rotten Row.

The Exhibition was opened by Queen Victoria on 1 May to the delight of the people, who shouted, 'Huzza for the Crystal Palace, And the world's great National Fair.' The Exhibition attracted over 6 million visitors from its opening to the 11 October, with an average of 43,000 daily. Its success was phenomenal; from a financial point of view, after expenses were deducted, there was a surplus of £150,000, with which the land from the park to South Kensington was purchased, and on which the Albert Hall and museums were built. It was the complete originality of the whole structure that captivated many of the visitors. In his memoirs, the eighth Duke of Argyll refers to the

Opposite: *The Great Exhibition of 1851*. James Duffield Harding, 1798–1863. (© Yale Center for British Art, Paul Mellon Collection)

opening as the most beautiful spectacle he had ever seen. Queen Victoria was 'quite beaten' by the vast glass miracle, 'and my head bewildered, from the myriads of beautiful and wonderful things, which now quite dazzle one's eyes!' It was indeed Albert's triumph. The palace was eventually moved, piece by piece, to Sydenham in south London, when the exhibition eventually closed. With the memory of the exhibition still fresh in people's minds, the site for the Albert Memorial was chosen. Described in detail later, the idea was conceived by Sir Gilbert Scott. When it was erected, an alteration was made to some of the avenues in Kensington Gardens, so as to bring one into line with the Memorial. A fresh avenue of elms and planes straight to the monument was planted, which joined into the original one, and a few trees were dotted about to break the old line.[22]

The 1850s also saw the Marble Arch erected to its present position. It originally stood in front of Buckingham Palace, placed there by George IV. Its gate had hitherto always been open for royalty to pass through. It was originally adapted by Nash, with the design of the arch based on that of the Arch of Constantine in Rome and the Arc de Triomphe du Carrousel in Paris. It was originally intended to carry a programme of sculpture celebrating British victories during the Napoleonic Wars. The upper part of the arch was reconstructed during its removal as a police station, to contain a reserve of men in case of emergencies. At about this time, too, the old yet romantic Cheesecake House of the Stuarts and Mr Pepys was demolished.

The Dell was also created at this time. The site of the Dell was a receiving lake, about 200 by 70 yards, which had been made in 1734. This was done away with in 1844, and the overflow of the Serpentine was allowed to pass over the artificial rocks that still remain. It was, at the time, the 'haunt of all the ruffians and the worst characters who frequented the Park at night'. It was no thing of beauty, and it was in this state when Lord Redesdale became Secretary of the Office of Works in 1874. He conceived the idea of turning it into a subtropical garden, designed the banks of the little stream and introduced suitable planting, banishing the old shrubs and using the

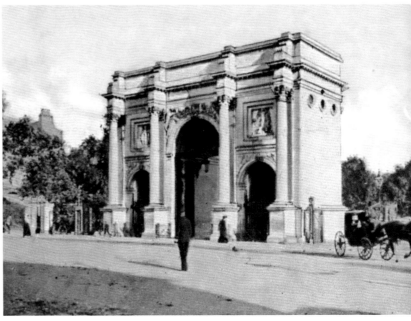

The Marble Arch, Cumberland Gate, Hyde Park, Illustrated London News, 24 May 1851.

Nash's Marble Arch was originally intended to carry a series of sculpture celebrating British victories during the Napoleonic Wars. It now stands in a peculiar position in the middle of a traffic island.

Opposite: *General View of the exterior of the Crystal Palace, Hyde Park.* Taken from Dickinson's comprehensive pictures of the Great Exhibition of 1851. Originally published in 1854.

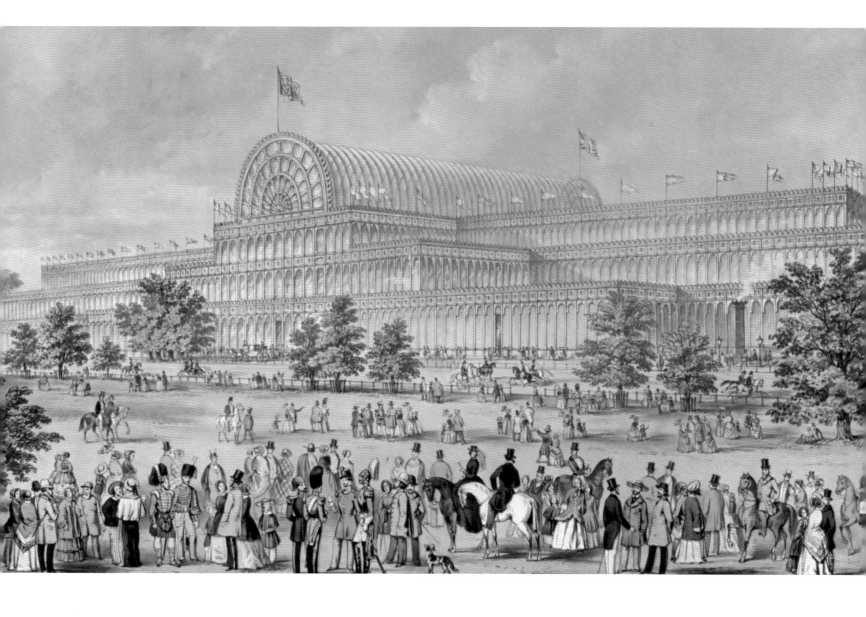

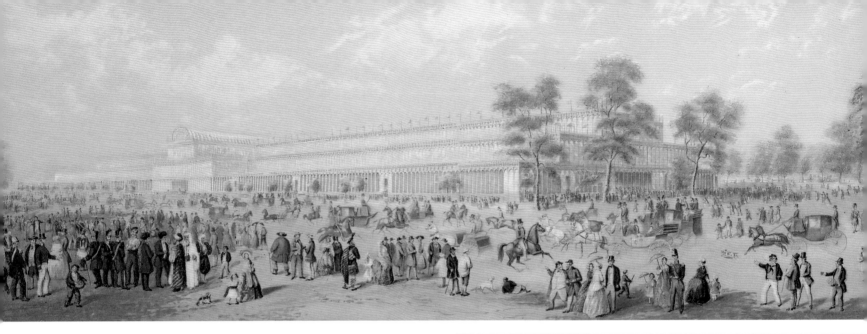

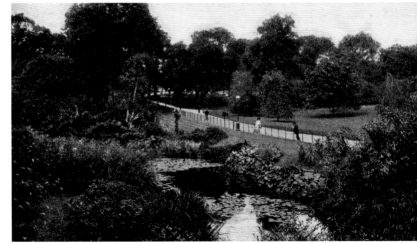

best to form a background to the *spiraeas*, iris, giant coltsfoot, *osmundas*, day lilies and suchlike that adorned the water's edge. The Dell remains one of the prettiest spots in Hyde Park to this day.[23]

Riding on Rotten Row was still as popular as ever, but the divisions between class and sex were very apparent. The fashionable world made Hyde Park, now embellished with flowers since 1860, the place to be. The nineties saw ladies turning out in droves on bicycles, with the police 'terrified of their speed'. However, during the latter part of Victoria's reign, more and more of the working classes were now using Hyde Park, as London grew and the countryside became more distant. The fairs at the beginning of the century had been important in changing the public attitude towards Hyde Park, and in revealing it as a place where one could take one's food and picnic and even skate on the Serpentine during cold winters. But it was during this time that Hyde Park gradually became the people's forum.

On 24 June 1855, oratory invaded Hyde Park. A meeting was publicly announced to take place there at 3 p.m. to protest against Lord Robert Grosvenor's Sunday Trading Bill. Despite efforts to prevent this, democracy took up the challenge; by 2.30 p.m. about 150,000 people had assembled in Hyde Park, including Karl Marx, and an orator started speaking, while the crowd heckled the wealthy promenaders of Rotten Row with shouts of 'Go to Church'. Despite the police attempting to arrest the orator, he got away and a battle ensued. The next day, however, Lord Robert withdrew the Bill. On Sunday 14 October, about 5,000 people gathered in Hyde Park and were addressed by 'a man of serious aspect' about the high price of bread. These were the beginnings of regular meetings, some of which ended in riots, including an instance when 'partisans both of Garibaldi and of the Pope arrived in Hyde Park, to the extent of eighty or ninety thousand on both sides. About four hundred police were there to keep them in order.' In 1886, the Reform League attempted a meeting again, despite the presence of 1,700 police and the closure of all the park gates. This resulted in two

Above: The Dell in 2014, still very popular but with no public access.

Opposite above: *The Great Exhibition: Exterior View From the Southwest*. 1851. Print made by George Baxter, 1804–1867. (© Yale Center for British Art, Paul Mellon Collection)

Opposite below left: *Gems of the Great Exhibition No. 4: The Foreign Department. 1852–1854*. Print made by George Baxter, 1804–1867. (© Yale Center for British Art, Paul Mellon Collection)

Opposite below right: The Dell during Victorian times.

days of rioting, in the course of which ten police superintendents, eighteen inspectors, twenty-three sergeants and 170 constables were 'slightly injured' and one superintendent, two inspectors, nine sergeants and thirty-three constables 'rendered unfit for duty'. After a good deal of wrangling it was discovered that there was only the law of trespass to keep people from holding meetings in Hyde Park. This discovery no doubt saved a good deal of further trouble. At subsequent meetings the police arrived in much greater force, but, making no attempt to prevent the meetings, were not molested. In October 1872 a notice was posted near a certain tree, which had become known as the Reformers' Tree and which stood where several paths intersect. This read, 'No public address may be delivered except within 40 yards of the noticeboard on which this rule is inscribed.' With the growth of Trade Unions, demonstrations ultimately became quieter. A mosaic laid in 2000 now commemorates the tree, which was burnt down in 1875. The stump became a focal point for meetings and notices. Continued attempts by the authorities to stop them led directly to the birth of Speakers' Corner in 1872.

The last great event to be held in Hyde Park in the nineteenth century was held on 22 June 1887. It was Queen Victoria's Jubilee, and the queen herself gave a treat to 26,000 school-children, over the whole northern side of Hyde Park. Each was given a meat-pie, a cake, a bun and an orange, as well as a medal. Lemonade and ginger beer flowed, with multifarious amusements provided by Punch and Judy, peep shows, performing dogs, Aunt Sallies and Knock 'em Downs, while military bands dispensed patriotic music. The queen and the Prince of Wales arrived unexpectedly and gave presents to as many children as possible. In her declining years Queen Victoria was a frequent visitor to Hyde Park, frequently driving there twice a day – once in the morning and once in the late afternoon.

During the reign of King Edward VII, Hyde Park underwent a great transformation. The dawn of the twentieth century heralded significant changes and as early as 1906 the introduction of 'motor landaulettes and hansoms first plied at Hyde Park Corner'. King Edward was an early riser, and rode before breakfast in the Row. Manners became relaxed as he was no stickler for etiquette. King George V, like his father, was also an early-morning devotee of the Row. His reign was eventful in the history of Hyde Park. During the darkest days of the First World War, the first American troops in London paraded through the park. London turned out to greet them vociferously and their impact on public morale was significant within London.

Between the two world wars, various introductions were made to the park, none more controversial than Epstein's monument to the famous naturalist and novelist W. H. Hudson, introduced in 1925, which will be discussed later. During the General Strike of 1926, Hyde Park was used as a food depot for London and closed to the public. In the spring of 1930 Hyde Park took on yet another phase. For two hundred years there had been no swimming in the Serpentine, except in the early mornings, and even then only men and boys had been allowed to swim. But Mr George Lansbury had become First Commissioner of Works, with authority over all the public parks. Lansbury's public spirit was well known and it was not long before he set out to make Hyde Park a more cheerful place for young and old, men and women alike. Through his office, bathing establishments were erected on the Serpentine, which came to be known as 'Lansbury's Lido'. Older people had never needed any encouragement to bathe in the Serpentine, having always been well represented in the traditional early morning swim. Lansbury's innovation was twofold: it enabled Londoners to bathe at all times of the day, and opened the Serpentine for the first time for two hundred years, since it had been founded, to women. Since then it has become incredibly popular, with thousands bathing there annually. Naturally, some opposition occurred, including a woman doctor in 1932 who pleaded that she did not see any need for people to wear costumes in the Serpentine as Hyde Park was Nature's Park. Questions were also

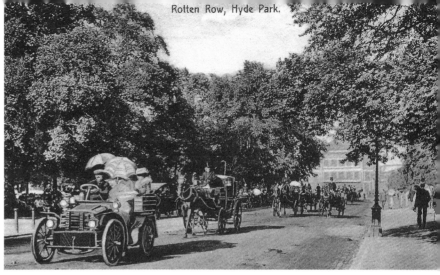

Rotten Row, Hyde Park.

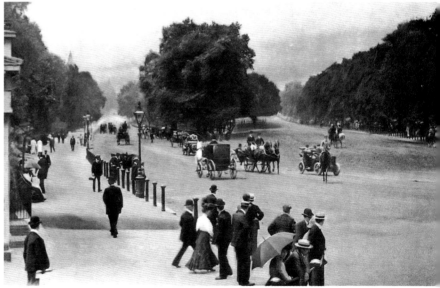

Above: Skating on the Serpentine in 1895.

Above right: Rotten Row in its heyday, when cars and carriages were commonplace.

Below: The Row in Victorian times.

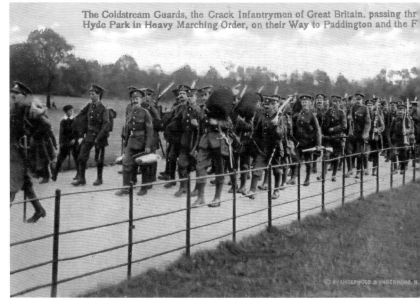

The Coldstream Guards, the Crack Infantrymen of Great Britain, passing thr
Hyde Park in Heavy Marching Order, on their Way to Paddington and the F

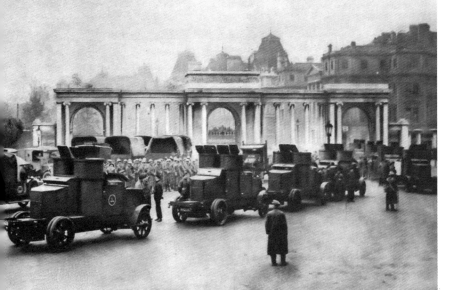

Above: The Coldstream Guards passing through Hyde Park on their way to Paddington and the Front during the First World War.

Above left: A saucy postcard of the Row, dated 1904.

Below: 'Aid to the Civil Power', which took place during the General Strike of 1926. This looks like a rendezvous point behind the Decimus Burton Screen.

asked in Parliament as to whether the Serpentine was a fit place to bathe and whether there was pollution caused by *streptococci* with so many people about in the water. Other issues were hotly debated in relation to Hyde Park, with ideas to brighten the park including Osbert Sitwell's proposal that the Crystal Palace should be put back in the park, as well as a 'great Winter Garden ... on continental lines'. Lansbury was an advocate of the latter proposal, which was to be built partly of glass, in a woodland setting, with the most suitable place on the rising ground near the Achilles Statue. Other improvements were hotly debated, including two classes of restaurant being introduced – one an expensive French model, and another a cheap German one.[24]

The short reign of Edward VIII in 1936 until his abdication was uneventful in relation to Hyde Park. He held a review of his Guards in July of that year, but he was rarely seen and was certainly not a frequenter of Rotten Row. Hyde Park by now was peaceful and tranquil. Cars faced the Serpentine and car-picnics were popular. 'A bird-man, a dear old man of about eighty, still talks to the birds every warm afternoon by the Flower Walk. The sparrows hop all over him.' The Ring Tea Gardens were popular and the birds here were known for their tameness. The herons policed the Dell and the swans were dominant on the Serpentine, but many visitors were now feeding the ducks. The largest animal in the park now was the sheep. Each year the park was grazed by a flock of about five hundred, the grass being offered annually for tender and the flocks arriving in May, when they were dipped and sheared in the little enclosure behind the Peter Pan statue in Kensington Gardens, and fattened until mid-August.

Writing before the outbreak of the Second World War, Eric Dancy concludes, 'Humanity is less faithful to such regime. The Church Parade has died hard: a few top-hats and prayer-books forgather still on Sunday

George Lansbury, the first Commissioner of Works.

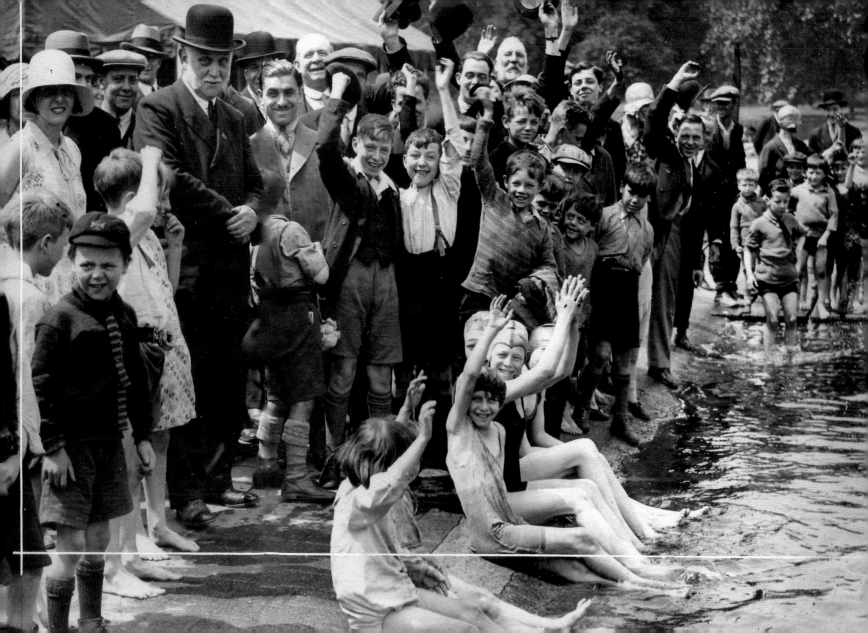

mornings near the Stanhope Gate, against a background of "mansions" so different from the old Park Lane, of which but few of the stately houses remain,' and so ends the pageantry of Hyde Park. Yet before the history of the park is brought fully up to date, the story must be told of the 'renowned orators' that authenticate Hyde Park as truly being the people's park.

Speakers' Corner is found close to the notorious site of the Tyburn gallows, where public hangings took place between 1196 and 1783. Legend has it the origins of Speakers' Corner lie in the tradition of allowing the condemned to make a speech from the scaffold. However, the right to speak in Hyde Park was formally acknowledged by the park authorities 80 years after the last hanging took place. Marches and protests have long been convened or terminated in Hyde Park, often at Speakers' Corner itself. In 1855 Karl Marx was moved to proclaim, 'The English revolution began yesterday in Hyde Park,' after witnessing demonstrations against the unpopular Sunday Trading Bill, which threatened to outlaw entertainment on the only day off ordinary people had. The origins of Speakers' Corner, as already described, can be found in 1866 from the time of the advent of the Reform League and the days of rioting that ensued in the park. The right to speak and meet freely in the park was formally acknowledged a few years later, in the 1872 Parks Regulation Act. The speaking area of Hyde Park as defined in legislation extends far beyond Speakers' Corner, but it is here where most people congregate. In addition, Hyde Park's long tradition of accommodating large public demonstrations and rallies continues today.

From 1906 to 1914 the suffragettes held both large and small meetings in Hyde Park as part of their campaign for votes for women. In the summer of 1906 they had a meeting every week near the Reformers' Tree. During the Women's Day of 21 June 1908, 250,000 women marched to Hyde Park to hear twenty different speaking platforms. In 1913 the police banned the Women's Social and Political Union from meeting in the park, but the

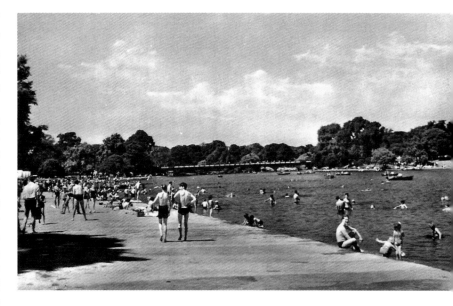

Above: Lansbury's Lido, which was then popular with swimmers, continues to be so to this day.

Opposite: George Lansbury visiting the lido on the banks of the Serpentine, among children who cheered him during the first swim in the new lido. June 1930.

suffragettes defiantly continued to do so. By the 1930s 'soapbox' orators were to be found in marketplaces, street corners and parks across the country. Of the estimated 100 speaking places found in London between 1855 and 1939, Speakers' Corner is the last to survive. On the outbreak of the Second World War, fiery socialist speaker Tony Turner stood up to denounce the war, reportedly gathering a crowd of several thousand. Speakers' Corner became a gathering place for refugees fleeing the Nazi advance through

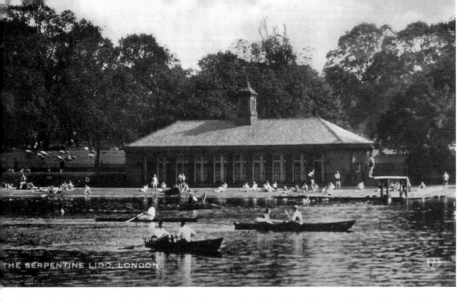

Above: Lansbury's Lido.

Below: A scene deep in the countryside? This is actually sheep grazing in Hyde Park, as was often the case.

Opposite: A heron policing the Serpentine. (© Debbie Brady)

Above: The Church Parade in Hyde Park, before the Second World War.

Above right: Workmen digging trenches in Hyde Park as zero hour approaches, 27 September 1938. The trenches were zigzagged for greater safety and were lined with planks and covered with galvanised iron.

Left: Religious rantings are commonplace today on Speakers' Corner.

Europe. Meetings even continued throughout the Blitz. The subjects discussed at Speakers' Corner throughout its history reflect the changing preoccupations of the day. The platforms of the 1940s, for instance, included the Connelly Association and United Irishmen, the Communist Party, the Socialist Party of Great Britain, Indian nationalists and African speakers. While political speakers continue to expound their views at Speakers' Corner to this day, the multitude of party political platforms are no longer to be found. Instead a greater number of religious meetings congregate at the Corner. Increasingly, the loudest debates take place between Christian and Muslim speakers and hecklers. Speakers' Corner was also the focus of a huge rally in February 2003 against military action in Iraq. The number of people who attended was estimated at between 750,000 and 2 million. The speakers and supporters included the actress Vanessa Redgrave, human rights campaigner Bianca Jagger, former MP Tony Benn, playwright Harold Pinter and the Hollywood actor Tim Robbins. The rally was one of the most recent in Hyde Park to have come about because of war. Speakers' Corner has continued to provide a focus for people to express their views about a range of topics, from voting rights to Sunday trading.[25] A contemporary writer who visited Speakers' Corner in 2013 described his experience:

> I listened to many reasonable, intellectual people discuss matters important to them and important to society and I listened to many more completely insane people discuss matters that are important to no one at all. I joined large crowds as we listened to speakers tell us why everything is evil and I must admit, I loved the whole experience. Eating meat is evil. Men are evil. The monarchy is evil. Democracy is evil. Capitalism is evil. White people are evil. Being fundamentally good is actually evil. Puppies are the evilest of them all. You name it, someone was ranting against it. I'll always remember the man who had literally no one listening to him but he still passionately continued on as if his speech on the merits of Atheism was being delivered at the UN General Assembly. I will remember the sweet old man who preached on the importance of feeding vegetables to the obese children. I will clearly remember the incredibly articulate, well-dressed man who stressed the importance of Pan-African nationalism to a large and energetic crowd, and I will absolutely remember the man wearing a full SS storm trooper uniform.[26]

For 140 years, Speakers' Corner has served as a platform for campaigners, preachers, ranters, ravers, the seriously opinionated and their hecklers — often all at the same time. Speakers' Corner is one small part of Hyde Park, but a significant part of its social history; it is the epitome of the people's park.

Above: The site of the former Reformers' Tree, which stood where several paths intersected.

Below: One of the many passionate speakers found among the people of Speakers' Corner.

Opposite: 'Jesus says ...'

Above: 'Please listen ...'

Below: 'Jesus My Lord and God ...' (© Debbie Brady)

Right: 'Time to go home ... it's been a long day on the Corner.' (© Debbie Brady)

Above: 'I quietly disagree ...' (© Debbie Brady)

Right: 'Beliefs.' (© Debbie Brady)

THE DEVELOPMENT OF KENSINGTON GARDENS

Hyde Park runs straight on into Kensington Gardens. Most visitors to this Royal Park, even native Londoners, probably can't tell exactly where one ends and the other begins. It is all one continuous walk, full of variety, flowers and fun, trees and statues, boats and babies. Apparently you get a nicer class of person in Kensington Gardens, so the locals say. It is the only London park with a real-life royal palace, full of real, live royal personages who have been spotted out in the park itself. Once you have crossed the Serpentine Bridge road, which bisects the two parks, you are in Kensington Gardens, and the atmosphere is indeed very different. There is no public road in Kensington Gardens, no horse riding or football playing, no rowdy public meetings. They are referred to simply as the 'Gardens'; there is an aloofness, a feeling of reserve, of being on a private estate. Yet the history of Kensington Gardens and Hyde Park is very closely linked, as previously mentioned.[1]

It was the joint reign of William and Mary that saw major changes in nearby Hyde Park that foreshadowed its future development, but it was the hiving-off of a large part of Hyde Park to create Kensington Gardens that had the greatest impact. It was ill health and William's chronic asthma that brought him and Mary to Kensington; the damp air and mists of the nearby Thames and pollution from the smoke of tens of thousands of chimneys made him seriously ill. In 1689, he was persuaded to recuperate at Hampton Court, close to the river but where the air was known to be fresh and clean. William, however, needed a place to live close to Whitehall that was healthy and invigorating, and it was Kensington that he turned to. The Earl of Nottingham, one of his most loyal servants, had inherited a Jacobean mansion on the western edge of Hyde Park in the village of Kensington. William bought it from Nottingham in July 1689 and immediately set about improving it. Ironically it was left to Mary to supervise these improvements, as William was frequently in Europe organising alliances or leading armies against the French. Mary took on the task with vigour and enthusiasm, visiting almost daily, and the royal couple moved in just before Christmas.

William needed a safe route from Kensington to Whitehall, and in 1690 the wide road was laid out that ran from the new home, along the southern boundary of Hyde Park to Constitution Hill, past Green Park and on to St James's Palace and Horse Guards Parade – the 'Route de Roi' which became Rotten Row. At the same time, the task of laying out the gardens for what was then known as Kensington House was given to Henry Wise and George London of Brompton Nurseries.

William was a keen gardener and his designs reflected his Dutch background, so inevitably Kensington House was laid out very formally with a central feature of a broad, tree-lined avenue, which ran down from the terrace in front of the King's Gallery. On either side were formal parterres planted with dwarf trees set in designs of box, often circular but also arabesque. The gardens were extensive and covered, at the time, up to twenty-six acres. Already some of Hyde Park had been absorbed, a forerunner of further encroachments. Even after the fire of 1691 works were to continue, and Mary was happy at Kensington. This was, however,

to be short-lived, and sadly she died of smallpox at the age of thirty-two, leaving William – who lived himself until 1702 – devastated.

He was succeeded by Anne, and Prince George of Denmark. They moved into Kensington and she immediately set to work on the gardens, employing Henry Wise and thus making him the most sought-after gardener in the country. Her changes were significant and her dislike of William's formal Dutch gardens resulted in their uprooting and replacement by a garden designed by Wise. It was no secret that Anne and William had never been on good terms. Undoubtedly, the most important development was her enclosure of no less than 100 acres of Hyde Park, to make a paddock for herds of deer and antelope. The gravel-pits behind the house were planted with trees and made into a much admired garden. Further improvements included the Orangery designed by Hawksmoor and Vanbrugh, which became Anne's 'Summer Supper House'. Anne's last few years brought her little happiness. George died in 1708 and Anne spent many of her hours driving herself around the gardens. Anne died in Kensington House on 1 August 1714, thus beginning the rule of the House of Hanover.

George I was fifty-four when he came to England, having lived in the palace of Herrenhausen, in Hanover, with its delightful gardens. These reflected in a more modest way the glories of Versailles, with formal avenues lined with trees, statues of amorous fauns and dryads, fountains and waterfalls. When George eventually came to Kensington, his main interest there was to extend the house into a palace and embellish the main apartments. For years he left the gardens very much as they were. He had a modest rectangular basin constructed, where his turtles could swim, and added a 'snailery'. In Queen Anne's paddock was a menagerie of tigers and civets. Water supply was an issue until the Chelsea Water Company was given permission to build the large reservoir in the Walnut Avenue in Hyde Park, and pipe a supply to the palace. Eventually, George turned his attention to the gardens and parkland beyond. In 1726, he approved an ambitious plan that had been prepared by the Royal

Gardener, Henry Wise, with his assistant Charles Bridgeman, who was an exponent of the new 'natural' style of landscaping soon to dominate the English scene. Significant preparatory work was carried out in 1727, but George died before he could see the gardens completed. It was Caroline, however, wife of George II, who enthusiastically implemented and extended the new developments, forming the framework of the Kensington Gardens which still remain today.

Taking over another 200 acres from Hyde Park, it was Charles Bridgeman who was now solely in charge of works. The formal gardens south of the palace were turned into lawns. Queen Anne's avenue, running from Bayswater to Kensington, was widened to fifty feet to make 'The Broad Walk' and lined with elms. The most significant works, however, were about to unfold. First, the large octagonal 'basin' (later the Round Pond) – set in a semi-circle of lawns and trees, leading the eye to the enchanting Long Water and Serpentine by three great, tree-lined avenues in *patte d'oie* style – was created out of the ponds of the Westbourne. Beyond were uninterrupted vistas of the wooded landscape of Hyde Park, and instead of the usual boundary wall or pales there was a ha-ha, a deep fosse or ditch. Bridgeman had created a park designed for civilised men and women, where they could walk and admire this elegant scene. A curious introduction completed in 1733 was a 'garden mount', built to a height of 150 feet, surrounded by a grove of trees and surmounted by a revolving summerhouse that enabled Queen Caroline and members of the court to enjoy looking down and around the splendid view. Below were her fine, new, tree-lined avenues, interspersed with copses and winding paths designed in the rococo style by William Kent, who, in addition to the summerhouse on the mount, also built 'The Queen's Temple'. The greatest view must have been to the east – the gracefully shaped expanse of the Long Water and the Serpentine of Hyde Park. Caroline's plans were even greater, but thankfully never realised. They included the building of a grandiose palace in Hyde Park and the closure of the park to the public. By the time of Caroline's death in 1737, the new gardens of Kensington Palace

were well established, and they were opened as a privilege to a limited public on Saturdays if the court were elsewhere, such as Richmond. Gate-keepers, however, were instructed only to admit those whose dress and deportment belonged to the upper and middle classes. Soldiers, sailors, servants and those poorly dressed were excluded, and as a result would gather outside the gardens, loudly mocking those who had been admitted.

George II outlived Caroline by twenty-three years and Kensington gradually declined, although the gardens were kept in reasonable order. He died in 1760 and was the last reigning monarch who resided at Kensington. His successor, George III, lived at St James's Palace and was in the process of buying Buckingham House.

Hyde Park was thriving and was the focus of many exciting events; by the nineteenth century Kensington Gardens were opened daily to the 'respectably dressed'. Queen Caroline's Mount was levelled, the ha-ha gradually filled in and ornamental trees and shrubs planted on the west bank of the Long Water, but most significant was the beginning of the Flower Walk, which stretches nearly a mile and was a sight to behold. Sheep were brought in to retain a sense of rural tranquillity. However, London was growing at such a phenomenal rate, with developers soon running out of building sites around Hyde Park, that ultimately they moved westwards to the environs of Kensington Gardens. In the 1840s several sites were leased along the western boundary of the palace for a number of villas; they were impressive buildings with a very grand, private road, lined with noble trees, and today are mainly embassies. These villas brought a new community of extremely rich tenants, who soon pressed for and obtained special privileges, including private entrances to the Gardens, ultimately leading to the replacement of the old walls with open iron railings. Development continued around Kensington in the south and along the Bayswater Road in the north, with the creation of new squares, terraces and crescents and the new shopping areas along Kensington High Street and in Notting Hill Gate.

Families grew in size during the Victorian age, and those with wealth had nannies and nursemaids, who were often seen parading with well-nurtured children in perambulators near the Round Pond. Further boundary walls were replaced with railings and more entrances created; public lavatories and tea rooms were built; statues including, as we know, the Albert Memorial, were erected and installed to commemorate the great and the good. By the Long Water the statue of J. M. Barrie's Peter Pan now stands on a pedestal, decorated with squirrels, rabbits and mice. Over in the children's playground is the Elfin Oak, a stump from Richmond Park, carved in the thirties by Ivor Innes with fairies and elves and pet animals. Dutch Elm disease took its toll in the 1950s and sadly the great avenues planted by Queen Caroline were lost, and were ultimately replaced with limes and maples. The Flower Walk continued to be a haven of peace and tranquillity in Victorian and Edwardian times. But despite Victoria growing up at Kensington Palace, and her childhood spent in and around the Gardens, she would never go back. There is still, however, a statue of her in front of Kensington Palace, looking out across the Broad Walk and the Round Pond where she played as a child, celebrating the first fifty years of her life.

Like many of the other Royal Parks, Kensington Gardens has evolved gently and peacefully into the twentieth century and beyond. Unlike its busy and bustling neighbour Hyde Park, Kensington Gardens has a smaller number of monuments and statuary, described later. It is perhaps best known for the huge outpouring of public grief when Diana, Princess of Wales, was tragically killed in 1997. She was a resident of Kensington Palace and, as a consequence, thousands of people left public offerings of flowers, candles, cards and personal messages outside the palace for many months after her death. 'A huge wooden pirate ship is now the amazing centrepiece of the Diana, Princess of Wales' Memorial Playground. This children's wonderland opened on the 30 June 2000, in memory of the late Princess. Located next to her Kensington Palace home, the playground is a fitting tribute for a Princess who loved the innocence of childhood.'[2]

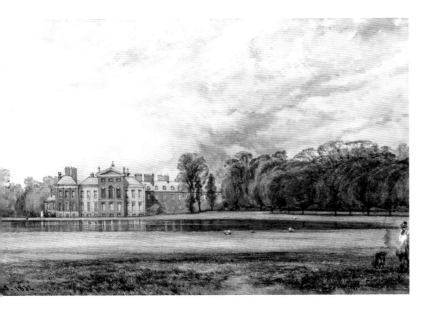

Above: *View of Kensington Palace from across the Round Pond*, 1832. William Evans of Bristol, 1809–1858. (© Yale Center for British Art, Paul Mellon Collection)

Right: *A Scene in Kensington Gardens*, 1782. Unknown artist. (© Yale Center for British Art, Paul Mellon Collection)

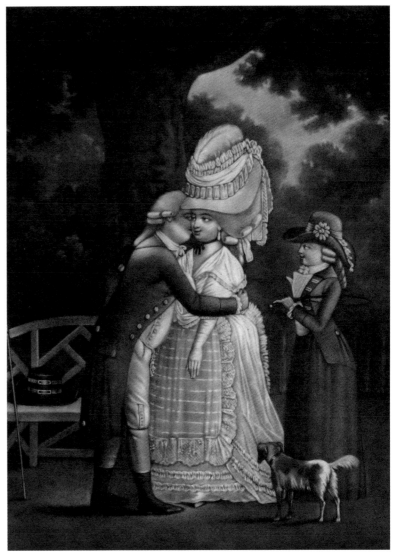

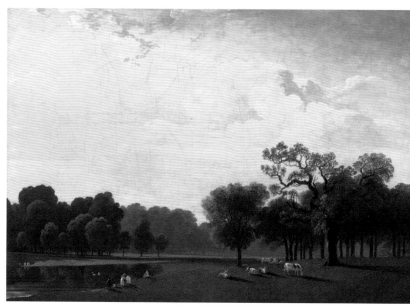

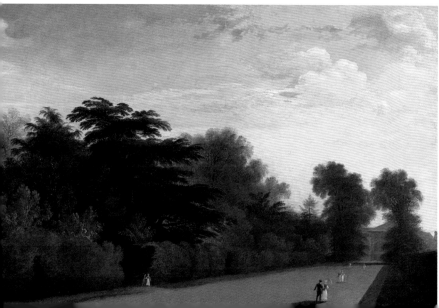

Above: Kensington Gardens, 1815. John Martin, 1789–1854. (© Yale Center for British Art, Paul Mellon Collection)

Above left: Kensington Gardens, 1815–1816. John Martin, 1789–1854. (© Yale Center for British Art, Paul Mellon Collection)

Below: Kensington Gardens, 1815. John Martin, 1789–1854. (© Yale Center for British Art, Paul Mellon Collection)

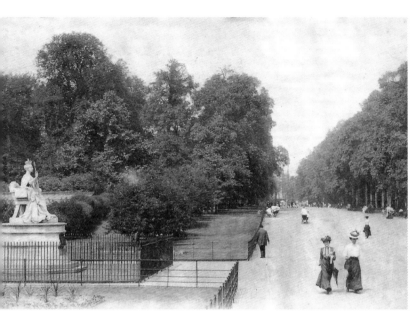

Above: Queen Anne's avenue, running from Bayswater to Kensington, was widened to fifty feet to make 'The Broad Walk' and was lined with elms. The Queen Victoria statue was sculpted in marble in 1893 by Princess Louise, Duchess of Argyll, and presented by the Kensington Golden Jubilee Memorial Executive Committee. The young queen is wearing coronation robes.

Above right: A flower walk in the gardens. The poet Thomas Tickell (1685–1740) described them thus: 'Where Kensington, luxuriant in her bowers, Sees snow of blossoms, and a wild of flowers.'

Below: Kensington Palace, surprisingly modest in scale with only two façades and the rest comprising buildings assembled around three courtyards.

Overleaf: The Round Pond in Kensington Gardens.

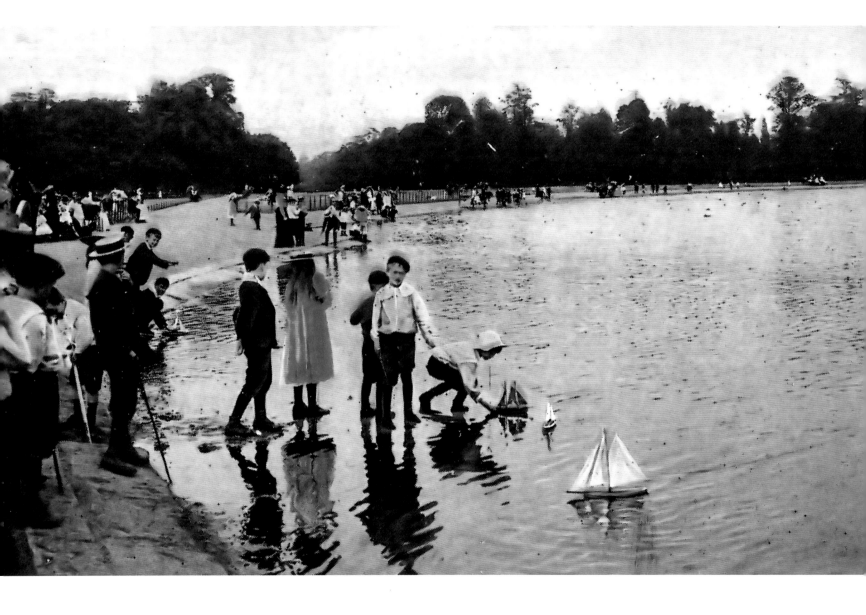

4

ARCHITECTURE AND ARTEFACTS

Hyde Park continues to enjoy the status of a Royal Park, yet it has been shaped more by the continued demands of the public and those who have used it for centuries than by the aspirations of any ruling monarch. On the occasions previously referred to, when a member of a royal family put forward the idea of a new palace in Hyde Park the proposal was swiftly squashed. Although the monarch and their guests continued to hunt in the park, Charles I changed its nature irrevocably when he opened it to the public around 1630, and it has remained the people's park since then. The only significant landscaping that has ever occurred in Hyde Park was the creation of the Serpentine, which also fell within the boundaries of Kensington Gardens. However, it was in the 1820s when the Commissioners of Woods and Forests took matters in hand, with a programme of improvements to the park. With the new buildings, railings and gates with lodges in a neo-classical style, Hyde Park was given dignity and a unified character it had previously lacked. With the Great Exhibition in the mid-nineteenth century and the advent of Speakers' Corner in 1871 as a venue for public meetings, the park was embellished in a typically High Victorian manner, with buildings and statues for the physical and moral benefit of the public. The process continued, although in a much more subtle fashion, throughout the twentieth century and now determines the character of Hyde Park. All the surviving buildings and monuments date from the last two centuries. Nothing remains of Charles I's hunting lodge, which may have been designed by Inigo Jones, nor the Cheesecake House where Pepys 'drank a cup of new milk', nor of the Duke of Gloucester's riding school. The buildings, unlike those in many of the other Royal Parks, are of limited architectural interest, but the many fine sculptures, artefacts and memorials more than make up for this.[1]

One of the finest and grandest entrances to any park is Apsley Gate, an elegant Greek Revival screen with an adjacent lodge by Decimus Burton. It was commissioned by the Office of Woods to replace earlier wooden gates. The fluted screen and entablature is in Portland Stone, embellished with friezes by John Henning in imitation of the Elgin Marbles and copied directly from the Parthenon sculpture. As previously referred to, alongside his work in Hyde Park, Burton was designing a new western approach to Buckingham Palace. Apsley Gate was planned as the final part of a route that would run from Nash's Marble Arch, (which then stood in front of the palace), through his own Constitution Arch into Hyde Park. Adjacent to the gate is Hyde Park Corner Lodge, built in 1822 by Decimus Burton, with a three-bay Greek Doric portico, erected in association with the gate.

Apsley House was the home of the Duke of Wellington, and he is commemorated by the Richard Westmacott statue which stands nearby. This was the first statue erected in Hyde Park, and on its unveiling in 1822 was highly controversial. Described as 'Achilles', the huge figure was cast in bronze obtained from cannons captured

in Wellington's campaigns. The image for Achilles was taken from a Roman group on Monte Cavallo, but its head was clearly modelled on the duke himself. The controversy was clear, as the ladies of England had commissioned it but, to their horror, the statue was nude. The press delighted in the ongoing controversy, and the offensive member was soon covered by a small fig leaf.

Just to the east of Achilles is one of the more recent introductions to the park – the Queen Elizabeth Gates, installed in 1993 in honour of the Queen Mother. Like Achilles over 170 years before, the gates attracted the wrath of the public. The central screen, by David Wynne, unites the lion of England and the unicorn of Scotland. Their sculptor, Guiseppe Lund, designed them to be 'feminine and fresh with the charm of an English garden', in deliberate contrast to the formal, masculine character of their setting. However, they have since been described by critics as 'appalling ... A music hall joke, a pantomime dame, and a seaside postcard rolled into one'. Lord Rogers described the design as 'romantic candyfloss' and compared it to one of the Queen Mother's hats. Even her grandson Viscount Linley said he 'absolutely loathed it'.[2]

To the north, adjacent to Park Lane, there is the Joy of Life fountain, which dates from 1963, when Park Lane was widened. It was donated by the Constance Fund, and its gravity-defying bronze figures were sculpted by T. B. Huxley-Jones and cast at Peckham Foundry. The Marble Arch was moved from Buckingham Palace in 1851. Nash had based his design on the Arch of Constantine in Rome and planned to finish it off with an equestrian statue of George IV. However, by the time Chantrey had finished the statue in 1843, Nash had been disgraced, so the statue ended up in Trafalgar Square. Cumberland Gate, which in the 1960s was shifted from its original position by Marble Arch, was once Tyburn Gate. It was renamed after the Duke of Cumberland. The gate lodge was built in 1857 as a copy of Decimus Burton's East Lodge. It too has been moved twice, but still retains its small clocktower.[3]

The West Carriage Drive delineates the boundary with Kensington Gardens. To the south of the Frame Ground (original glasshouses built 1903–07 when the Frame Ground was moved from Kensington Gardens, damaged by bombs in 1940 and replaced in 1951) there is a memorial to the writer and naturalist W. H. Hudson, who had studied the birds in the Royal Parks. There was uproar once again in the park when the memorial was unveiled by Stanley Baldwin in 1925. Despite the fact that the sides of the pool were too steep to allow birds to drink or bathe, the real affront lay in Jacob Epstein's relief carving of *Rima*, Hudson's spirit of the forest. To the assembled throng the sculpture seemed like an awkwardly carved figure of a distorted and explicitly nude girl surrounded by grotesque birds. A media campaign followed in which the *Morning Post* described *Rima* – or the 'Hyde Park Atrocity', as it was quickly dubbed – as 'Mr Epstein's nightmare in stone' and 'the most famous example of a great sculptor who has sold his soul to the devil'.[4] Fortunately, good sense prevailed; George Bernard Shaw, Sybil Thorndike and Augustus John lent their names to a letter in *The Times*, the artist Muirhead Bone argued their case with the Commissioner of Works, and the memorial remained. It is now considered one of Epstein's finest early works. Nearby is one of the finest buildings in the park. The Old Police House was built in 1900–02 on the site of the Magazine Barracks. It is a fine Queen Anne revival building and now the Headquarters of the Royal Parks and the Hyde Park Metropolitan Police Service. The Ranger's Lodge beside the path to the Serpentine was built in 1832, along with, just to the west, the Norwegian War Memorial (1978), a simple boulder of pre-Cambrian granite.

Boating was first allowed on the Serpentine in 1847; it has continued since then and remains extremely popular. However, the two present boathouses are fairly recent. The East Boat House, of 1903, was erected by the Royal Humane Society near their old Receiving House. The society was founded in 1774 to provide a rescue service for the Serpentine, which

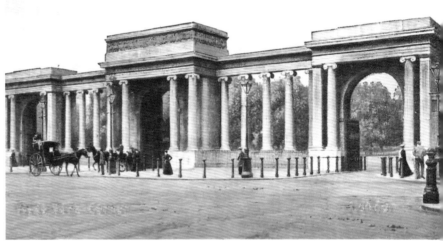

Above: Ionic screen, 1826–29, by Decimus Burton, commissioned by the Office of Woods to replace earlier wooden gates. The fluted Ionic screen and entablature are in Portland stone, embellished with friezes by John Henning in imitation of the Elgin Marbles.

Above right: Hyde Park Corner.

Below: Decimus Burton's Ionic screen today.

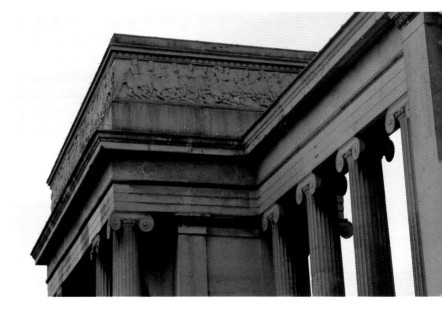

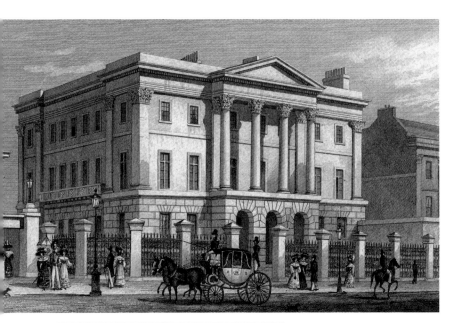

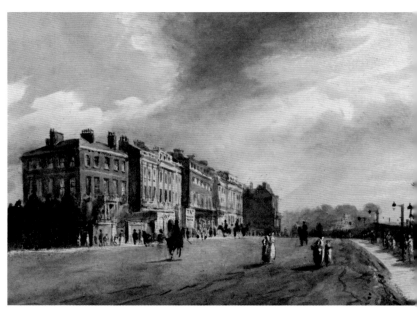

Above left: *Apsley House, Hyde Park Corner: The Residence of His Grace the Duke of Wellington*, 1829. Print made by Thomas Barber, *c*. 1768–1843. (© Yale Center for British Art, Paul Mellon Collection)

Above right: *Apsley House and Piccadilly … From Hyde Park Corner*. Frederick Nash, 1782–1856. (© Yale Center for British Art, Paul Mellon Collection)

Below: The statue of Achilles at Hyde Park Corner by Richard Westmacott.

Above: The Queen Elizabeth Gates, installed in honour of the Queen Mother in 1993.

Right: Intricate detail on the Queen Elizabeth Gates. (© Debbie Brady)

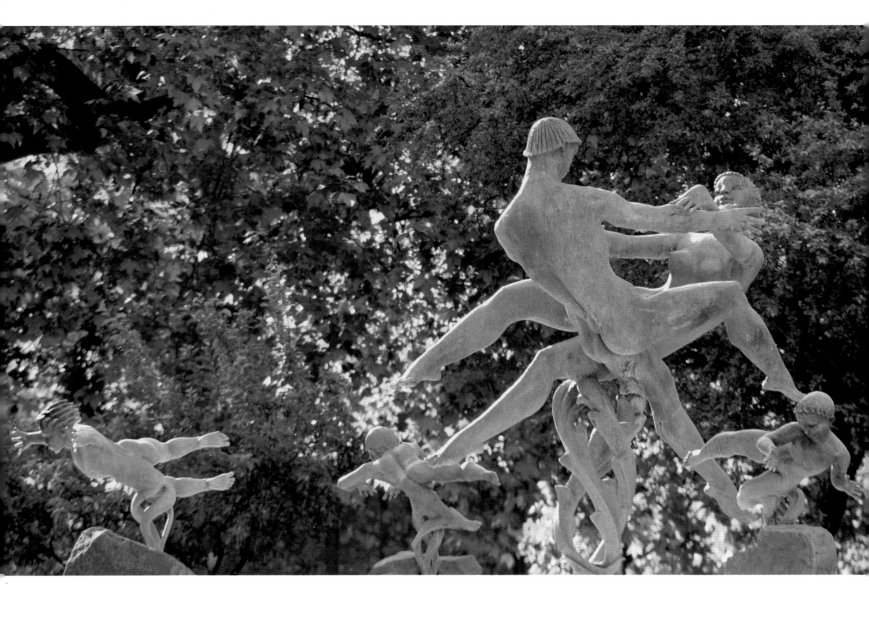

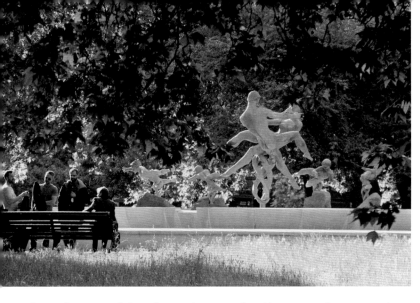

Above: The gravity-defying bronze figures sculpted by T. B. Huxley-Jones and cast at Peckham Foundry. (© Debbie Brady)

Above right: Metropolitan Police Officers, Rotten Row, Hyde Park. An 'A' division acting sergeant and police inspector attached to Hyde Park Police Station (AH), a sub-divisional station of Cannon Row Police Station (Alpha Delta), on duty in Rotten Row.

Below right: *Rima*, the Hyde Park atrocity.

Opposite: The Joy of Life Fountain.

The Old Police House, 1900–02, now the HQ of the Royal Parks.

has always been a magnet for drunks, revellers and suicides, and its first Receiving House was built in 1794. The West Boat House was put up in 1952 to replace one bombed in the war.

One of the more unusual buildings in the park is a porticoed lavatory, found close to the Reformers' Tree, built in the 1900s. Beside it is a drinking fountain by Theo Crosby for the 1981 Year of the Child, when 180,000 children attended the Great Children's Party. It was erected as a tribute to the park staff. To the south, close to the North Ride, is the Little Nell fountain, a stone replica of the 1896 bronze original by W. R. Colton. The nearby bandstand was originally erected in 1869 in Kensington Gardens and moved to Hyde Park in 1886. Beyond the bandstand is the Cavalry Memorial, erected in 1924 by Adrian Jones, who spent twenty-four years as an army veterinarian. It depicts a fifteenth-century warrior in the guise of St George, and was cast from bronze from guns captured in the First World War. Within the Dell is found a rather unusual megalith. This bizarre assembly is all that remains of the 1861 drinking fountain that was constructed around Cornish stones. Nearby stands the rather more dignified stone memorial to the Holocaust.

The Dell Restaurant was built in 1965, designed by Patrick Gwynne, and is one of the few modern buildings in the Royal Parks of any true architectural merit. It replaced the Ring Tea House. In 1963 Geoffrey Rippon proposed new catering facilities for Hyde Park to be built by private caterers. A limited competition for Forte's two sites in the park won Gwynne the commission to design the Serpentine and Dell Restaurants. Gwynne incorporated two basic ideas of 'shelter' and 'outlook' into his design in order to enhance the experience of Hyde Park to visitors; this was done by providing conservatory-type buildings with umbrella-like solutions for the roofs. Terraces were high, raised well above water level, not only to provide panoramic views across the Serpentine but also to accommodate the concealed service rooms beneath. Car-parking for visitors was kept out of sight. All this was achieved despite tight budgets, difficult planning restrictions and a rushed programme, and remarkably the Serpentine Restaurant was open by 1965. Gwynne designed the original interior fittings and furniture with an emphasis on high levels of finish. His obituary in *The Times* (8 May 2003) described Gwynne's 'much-loved restaurants in Hyde Park' and regretted the demolition of the Serpentine Restaurant in 1990. The Dell Restaurant does survive and received Grade II listing status in January 1995. Its listing notes praise the Dell as 'particularly imaginative in its light weight, tent-like form and use of materials'. These materials include an unusual floor clad in rare Brescia Violetta marble and a balcony with pre-cast terrazzo seating that cantilevers over the lake.

Beside the Dell restaurant is the Abbey Spring monument, dating from 1868 – an urn marking the ancient spring that supplied water to

Above: Hyde Park still has a fleet of rowing boats, now supplemented by pedal boats, which operate on the Serpentine.

Below: *Royal Humane Society's Receiving House in Hyde Park.* Print made by unknown artist. (© Yale Center for British Art, Paul Mellon Collection)

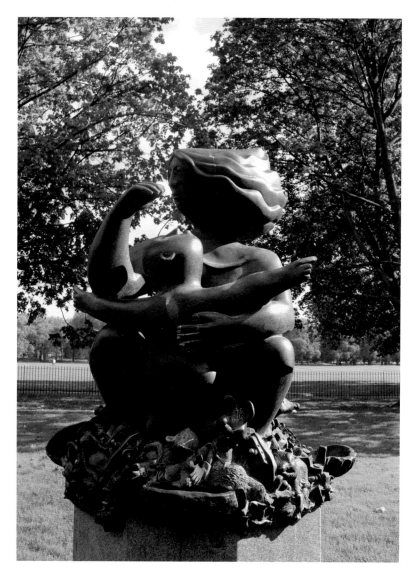

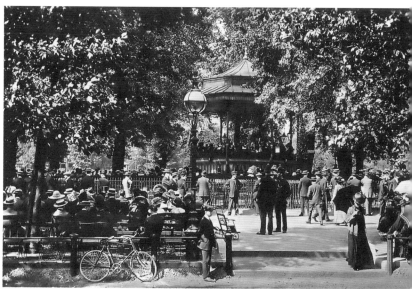

Above: The bandstand, popular in Victorian times and still very much so today.

Left: Year of the Child drinking fountain, 1981, by Theo Crosby.

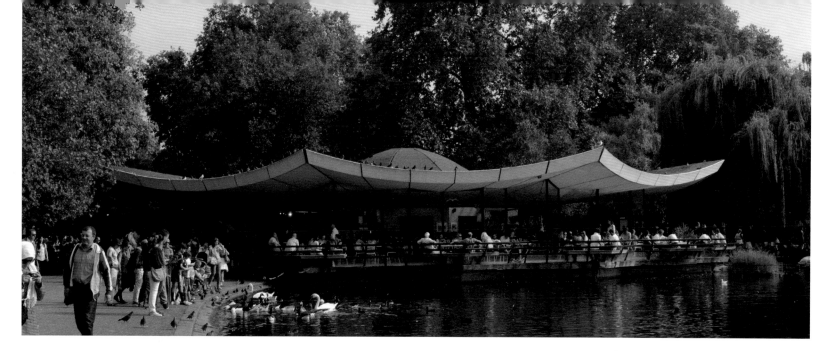

Above: The Dell restaurant by Patrick Gwynne, to replace the Ring Tea House.

Right: The restored bandstand in Hyde Park.

Top: Afternoon tea on the Dell Restaurant terrace, overlooking the Serpentine. (© Debbie Brady)

Above: A busy afternoon by the Serpentine.

Left: A detail of the Cavalry Memorial by Adrian Jones in 1924; it uses bronze cast from guns captured in the First World War.

Westminster Abbey. The right was granted by Edward the Confessor and continued until the conduit was cut off by the Metropolitan Railways in 1861. By the bridge there is the more elegant urn in memory of Queen Caroline.

To the south of the Dell is Rotten Row, which was, as previously mentioned, the creation of William III to link Whitehall with his new palace at Kensington. It was described in 1695 by Celia Fiennes as 'a high causey of a good breadth, 3 coaches may pass, and on each side are rowes of posts on which are Glasses – cases for Lamps which are lighted in the evening and appears very fine as well as safe for the passenger'. The railings were melted down in the Second World War and replaced, with the cost born by the sponsors whose names appear on the posts.

The other fine building that remains within the park is the Lido Pavilion on the banks of the Serpentine, which was built in 1930 to provide the mixed bathing and sunbathing facilities demanded by the Sunlight League. As previously described, Lord Lansbury, the First Commissioner of Works, was keen to improve the recreational facilities during the Depression years and had made an appeal for funds. The pavilion was erected with the help of £5,000, donated by Mr D'Arcy Cooper in memory of his son. George Lansbury had set out to make Hyde Park a more cheerful place for young and old, men and women alike. Looking across the Serpentine from the Lido Pavilion is the fine Serpentine Bridge, which was built 1825–8 to a design by George and John Rennie. Prior to its introduction, a small cascade marked the junction between the two lakes; the new bridge created a thoroughfare that totally changed the character of Hyde Park.

The route back to Hyde Park Corner by the South Carriage Way is marked by a series of sculptures and memorials, as well as the nearby Diana, Princess of Wales Memorial Fountain, a memorial dedicated to the princess. It was designed to express Diana's spirit and love of children and was opened in July 2004. Diana was seen as a contemporary and accessible princess, so the goal of the memorial fountain was to allow people to access the structure and the water for quiet wading and contemplation. However, shortly after its opening and three hospitalisations caused by people slipping in the water, the fountain was closed. It reopened in August 2004 surrounded by a new fence, and people were prevented from walking and running in the water by six wardens. Now, however, entering the water is again permitted. Even though the fountain was open only for part of the 2004 season, and the weather was not particularly wet, the grass adjacent to part of the fountain was badly damaged and it appeared that it would turn to a quagmire if heavy rain ever fell during the main visiting season. Thus, in December 2004, another alteration project was started. This involved work on the drainage, together with laying new, hard surfaces on some of the most frequently walked areas of the site and the planting of a special, hard-wearing rye grass mix. Today it is enjoyed by many of the millions that visit Hyde Park uninterrupted. Other features include the fine pair of stags on the Albert Gate. On the left is a simple memorial to soldiers of the Household Cavalry killed by the terrorist bomb attack in 1982. A horse-trough nearby commemorates the horses that died in the blast. Finally, in the enclosed garden, there is a rather bland depiction of Diana the huntress (1906) by Countess Feodora Gleichen, and a Boy and Dolphin by Alexander Monro. This was once the centrepiece of the Victorian sunken garden (1860–2) that was demolished to make way for Park Lane and has been replaced by the Joy of Life fountain.[5]

Kensington Gardens is effectively a 'layered landscape', in which the early Georgian formal garden is overlaid with the decorative features of a Victorian park. The buildings and monuments therefore fall into two groups. Firstly, there are those associated with the creation of the palace and its gardens, from the 1690s to the 1730s, which included distinguished works by Christopher Wren and William Kent. Secondly, there are those of the Victorian and Edwardian eras, when the gardens became a fashionable public park.

Top: The Lido Pavilion, built in 1930 under the direction of George Lansbury and reconstructed in 1951–2.

Above: Bathing in the Serpentine.

Left: Relaxing in the Serpentine by the Lido Pavilion. (© Debbie Brady)

Right: The Diana, Princess of Wales Memorial Fountain. (© Debbie Brady)

Far right: Splashing about in the Diana, Princess of Wales Memorial Fountain. (© Tracy Crane)

Soaking up the sun but keeping cool in the Diana, Princess of Wales Memorial Fountain.

The Broad Walk in Kensington Gardens is entered by Palace Gate and was planted by Bridgeman. Its original elms were replaced in 1954 with limes and maples. At the end of the Flower Walk is the Esmé Percy Memorial (1961) by Silvia Gilley. Further up the Broad Walk is St Gover's well, which marks the site of an ancient spring and was once considered to have medicinal properties. It was named in 1856 after the patron saint of Llanover by Benjamin Hall, the first Commissioner of Works, who later became Lord Llanover. The present Portland-stone cover dates from 1976. The bandstand in Kensington Gardens was put up in 1931, the earlier one having been moved to Hyde Park. Queen Victoria gave permission for music to be played in the gardens in 1855, unwittingly creating a public uproar. The Archbishop of Canterbury objected to the music and the Keeper of the Privy Purse agreed. The latter, although believing that the 'recreation and amusement of the class who are confined during the week is of great importance', did not think 'military music a necessary ingredient of it'. The queen rescinded her permission and the first bandstand, near Mount Gate, was not erected until 1869.[6]

Kensington Palace lies at the top of the Broad Walk and for a royal residence in the age of Louis XIV it is surprisingly modest in scale. There are only two grand facades and the rest comprises buildings assembled around three courtyards. The south front, which was built 1689–95 for William III, contains the King's Gallery. The east front was rebuilt 1718–26 for George I, and is centred on a fine Venetian window that reflected the new Palladian style. The large and flat expanse of lawn to the south of the palace was once William and Mary's Dutch garden. The Crowther Gates used to be on the north side of the State Apartments, but were installed here in 1989. Behind them there is rather a large bronze statue of William III by H. Baucke, presented to Edward VII for the British nation by his nephew, the German Kaiser Wilhelm II, in 1907. The east façade of Kensington Palace faces the Round Pond. In the reign of George I this was a small rectangular basin that housed the king's 'tortoises' or turtles; beside it was the 'snailery' and nearby the tiger's den. The marble statue of Queen Victoria is close by. Erected in 1893, it is by her daughter Princess Louise and shows the queen at her coronation. Victoria was born at Kensington Palace and grew up there under the strict supervision of Sir John Conroy, until summoned from her bed in 1837 to become queen.

Beyond the statue are the two wonderful gardens that were laid out in 1908–09. The Sunken Garden recalls that planted for Queen Anne, but is modelled on a Tudor garden at Hampton Court that had recently been restored. The nearby topiary garden provides a perfect formal setting for the beautiful Orangery that is Queen Anne's most important legacy to the gardens. It was built in 1704–05 to a design by Hawksmoor, though it was

later altered by Vanburgh and used for her summer supper parties. North of the Orangery is the playground, which was constructed in 1909; its first swings were the gift of J. M. Barrie. Beside it is the Time Flies drinking fountain, given in the same year by a Mrs Galpin. Its cosy yet stern design is a reminder of passing time, evoking those vanished Edwardian childhoods when nannies to the nobility had their own benches and Peter Pan lived in the gardens but 'the children never caught a glimpse of him'. The Elfin Oak, riddled with tiny gnomes, was added in 1930 as a result of Lord Lansbury's appeal to improve facilities in the Royal Parks. The 800-year-old tree trunk came from Richmond Park and the sculpture was by Ivor Innes.

The granite obelisk of the Speke Monument punctuates the north-east *allée*. Its inscription is cryptic – 'In memory of Speke – Victoria Nyanza and the Nile – 1864'. John Hanning Speke (1827–64) was the Victorian explorer who discovered the source of the Nile. However, his discovery was surrounded by contention. He died on the very eve of a crucial debate about it with Sir Richard Burton, when his own shotgun went off accidently during a partridge shoot. Some thought Speke might have committed suicide. At any rate, Sir Roderick Murchison, President of the Royal Geographical Society (RGS), who had called for the debate, now called for a monument to be erected by public subscription in this prominent location — not far from the RGS's present headquarters on Kensington Gore. Over 2,000 mourners attended Speke's funeral, and advertisements for subscriptions were placed even in the Delhi Gazette in India. Nevertheless, it was hard to garner the funds. When at last the monument was erected, no unveiling was reported either in *The Times* or in the Royal Geographical Society's own journal.

Beyond the monument, at the head of the Long Water, are the magnificent Italian Gardens, which were constructed in 1860–1 when the Westbourne river was cut off and a new well sunk to supply the park with water. Their formal architectural style conflicts somewhat with the pastoral setting of the park. Behind the Italianate loggia, which doubles as a pump house, are the arched remains of a former head wall outlet. Overlooking the garden is a statue of Edward Jenner, the country doctor who developed the smallpox vaccine. It was sculpted by William Calder-Marshall and originally placed in Trafalgar Square. Despite Jenner's undoubted fame, this was considered too grand a position and in 1862 the statue was moved. *Punch* was typically scathing on its demotion.

> England, ingratitude still blots
> The escutcheon of the brave and free;
> I saved you many million spots,
> And now you grudge one spot to me.

The Queen Anne's alcove is a fine piece of classicism by Christopher Wren and stands by Lancaster Gate. It was made in 1705 for the southern boundary of the queen's formal south garden, but moved to its present position in 1867 when it was considered unsightly and a resort for undesirable persons. Another important and popular monument in Kensington Gardens is the Peter Pan statue by Sir George Frampton, found on the west of the Long Water. It was erected in 1912 and was immediately voted the most beautiful of London's statues. The colossal statue of Physical Energy by George Frederick Watts is immense. Its history dates back to 1870 when Watts made an equestrian monument to an ancestor of the Duke of Westminster. In 1902 the artist was invited to make two casts: one as a memorial to Cecil Rhodes in Cape Town, and another for Kensington Gardens. He explained the concept as 'a symbol of that restless physical impulse to seek the still un-achieved in the domain of material things ... This is a symbol of something done for the time, while the rider looks out for the next thing to do.'

Overleaf: The Sunken Gardens at Kensington Gardens.

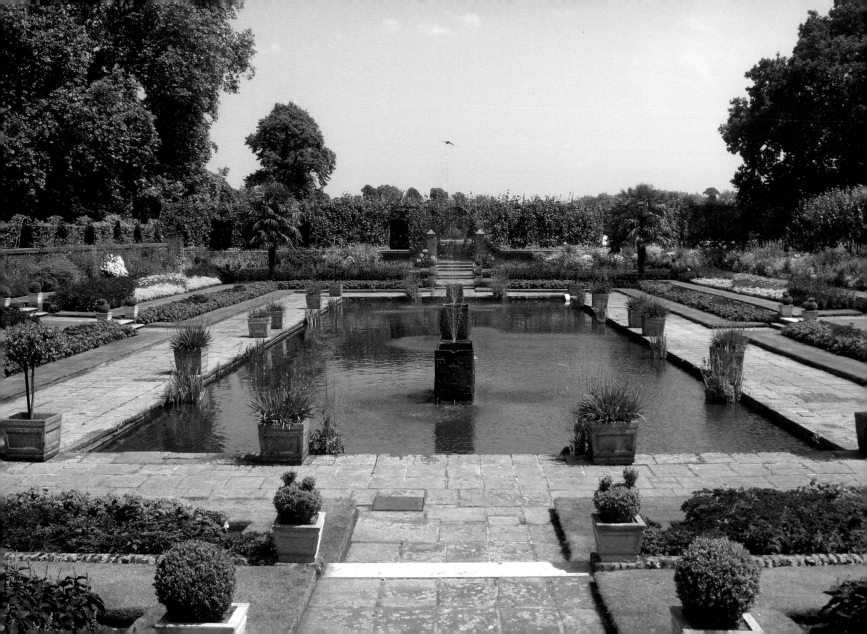

Above: The Queen's Temple, *c.* 1734, attributed to William Kent.

Left: Edward Jenner (1749–1823), 1858, by William Calder-Marshall, bronze, moved from Trafalgar Square as part of the Italian Garden works.

Opposite: The Peter Pan bronze, 1912, by Sir George Frampton, as commissioned by J. M. Barrie.

Overleaf: The Italian Garden was the idea of Prince Albert, who commissioned landscape designer Sir James Penethorne (1801–71) to design the layout. (© Dave Cutts)

The remaining buildings and monuments are some of the greatest in any of the Royal Parks. The beautiful Queen's Temple sits on a rise between the statue of Physical Energy and the Serpentine Gallery. It was designed for Queen Caroline in 1734–5, attributed to William Kent, and preserves the Arcadian spirit of the queen's landscaping. In 1835 it narrowly escaped being turned into a 'Mohamedan' summerhouse, but was soon enlarged to provide accommodation for the labourers' foreman. It was bomb-damaged in 1944 and restored in the 1970s with the lodge removed. The Serpentine Gallery was built as a refreshment room in 1934, but now displays exhibitions of contemporary art. In 2013 it was the subject of a major new expansion. The new Serpentine Gallery Pavilion was designed and built by multi-award winning Japanese architect Sou Fujimoto. This intricate and unusually latticed structure of 20 mm steel poles has a lightweight and semi-transparent appearance so that it blends into the landscape, and contrasts with the classical backdrop of the Gallery's colonnaded east wing. The Powder Magazine, a Palladian-style villa across the Serpentine Bridge, was built in 1805 and remodelled in the 1820s, probably by Decimus Burton, and eventually became a tea room. It has since been further restored to a design by Pritzker Prize-winning architect Zaha Hadid into a new 900-metre-square gallery space. A white undulating roof now creates a striking modern extension to the historic structure, which is a short distance from the original Serpentine Gallery. The new Serpentine Sackler Gallery – named after Dr Mortimer and Theresa Sackler, whose Foundation made the project possible – shows a mix of contemporary art, architecture, dance, design, fashion, film, literature, music, performance and technology. Like the Serpentine, this spin-off gallery is free to visit and is a significant addition to London's modern art scene. In contrast to these contemporary constructions, the Coalbrookdale Gates – the most splendid in the park – at the south end of the West Carriage Drive were designed by Charles Crookes for the Great Exhibition of 1851 and moved here during the construction of the Albert Memorial. Each of the cast iron gates, with its elaborate curlicues, was cast in one piece. Their finials, supporting a crown, represent Peace and the stags' head vases evoke the origins of the park.

However, the greatest monument in the gardens is the Albert Memorial, which was erected 1864–72 to a design by George Gilbert Scott. It was funded by public subscription as a 'tribute of ... gratitude for a life devoted to the public good', though in truth the earnest, cultivated German prince had never been much liked in Britain. Scott envisaged the memorial as 'a kind of ciborium ... on the principle of the ancient shrines ... to protect a statue of the Prince. These shrines were models of ancient buildings, and my idea was to realise one of these imaginary structures with its precious metals, its inlaying, its enamels, etc.' The statue of the prince, seated and holding the Great Exhibition catalogue, was by J. H. Foley and was once gilded. It forms the centrepiece of an elaborate sculptural programme that reflects the prince's diverse interests and virtues. Around the base are the four Continents that contributed to the Great Exhibition. Above, on the podium, are the Industrial Arts: Agriculture, Manufactures, Commerce and Engineering. The frieze, one of the masterpieces of Victorian sculpture, depicts the Western cultural tradition in a procession of poets, musicians, artists and architects. At the corners of the shrine stand the Great Sciences – Geometry and Physiology, Astronomy and Rhetoric, – while the Virtues and Angels bring it to a glorious conclusion. The work of many artists, it remains a permanent witness to the dynamism and assurance of the Victorian age.[7]

Opposite: Physical Energy, erected in 1907, by George Frederick Watts. (© Grace Evangeline)

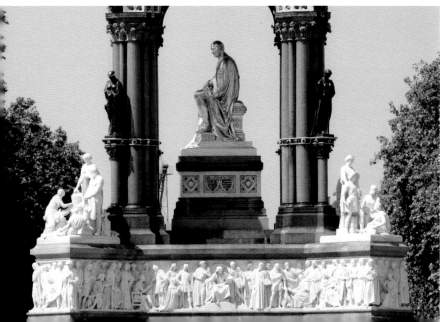

Above: The Albert Memorial.

Below: Statue of Prince Albert, 1875, by John Henry Foley and completed by G. F. Teniswood. (© Debbie Brady)

Opposite: The Albert Memorial, designed by Sir George Gilbert Scott. (© Debbie Brady)

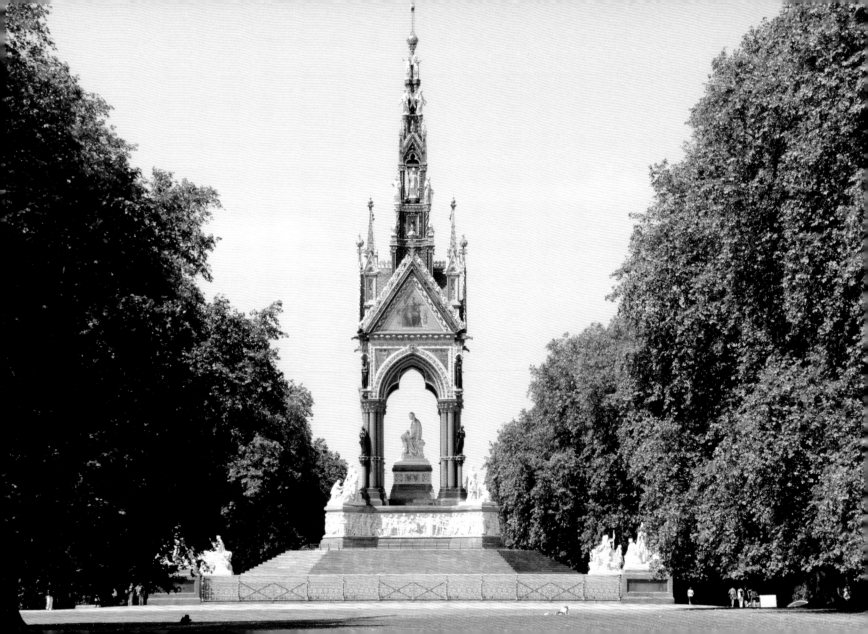

HYDE PARK TODAY

Hyde Park has continued to enjoy a public outlook. As George Orwell wrote in 1945,

> The degree of freedom of the press existing in this country is often over-rated. Technically there is great freedom, but the fact that most of the press is owned by a few people operates in much the same way as State censorship. On the other hand, freedom of speech is real. On a platform, or in certain recognised open air spaces like Hyde Park, you can say almost anything.

It has been the scene of many 'Parties in the Park', reminiscent of the scale of the reviews held throughout its long history. It has continued to be enjoyed by the masses throughout the twentieth century and into the early part of the twenty-first century. Hyde Park has hosted Orwell, Lenin and Marx, and more recently Bruce Springsteen, Bon Jovi and Black Sabbath. A venue for mass celebrations since VE Day, and for public events including Proms in the Park, it was also host to events in the London 2012 Olympic Games. It has housed in the last hundred years or so a pet cemetery, allotments during the First World War's Dig for Victory campaign and an exhibition to mark Queen Elizabeth's Silver Jubilee in 1977. This is truly the greatest park in London and one of the finest places to visit in England's capital. Here you can ride horses, swim or row in the Serpentine, play tennis, go in-line skating, dine, meditate, mediate and demonstrate. Or you can simply lie on the grass and watch the world go by. Writer Max Schlesinger wrote in 1853, in his book *Saunterings in and about London,* his description of Hyde Park based on the people within it. It is a perfect summary of Hyde Park.

Early in the morning the lake is plebeian. The children of the neighbourhood swim their boats on it; apprentices on their way to work make desperate casts for some half-starved gudgeon; the ducks come forward in dirty morning wrappers. Nursery-maids with babies innumerable take walks by order; and at a very early hour a great many plebeians have the impertinence to bathe in the little lake. But today the park and the river are in aristocratic splendour; here and there, there is indeed some stray nursery-maid walking on the grass, and some little tub of a boat with a ragged sail floating on the lake; there is also a group of anglers demonstrating to one another with great patience that the fish won't bite today, but all along the banks of the river far down to the end of the park and up to the majestic shades of Kensington Gardens there is an interminable throng of horses and carriages.

An incident that occurred in 2010 represents the continued importance of Hyde Park as the people's park. Two Tory MPs, Edward Leigh and Desmond Swayne, furious at being prevented from getting to the water during a spell of freezing weather, tabled questions in the House of Commons demanding to know why the historic access had been denied. The irony was that this pair of Tory MPs succeeded in preserving their freedom to swim in a lido commissioned by George Lansbury, a renowned pre-war socialist and future leader of the Labour Party. The revolution continues.

Opposite: Black Sabbath live in Hyde Park, 4 July 2014. (© Franke Rooke)

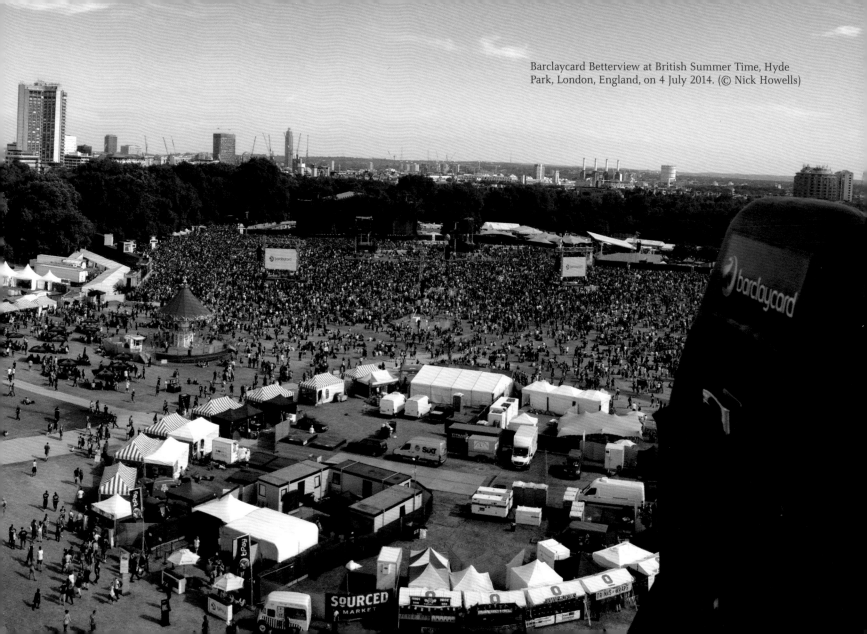

Barclaycard Betterview at British Summer Time, Hyde Park, London, England, on 4 July 2014. (© Nick Howells)

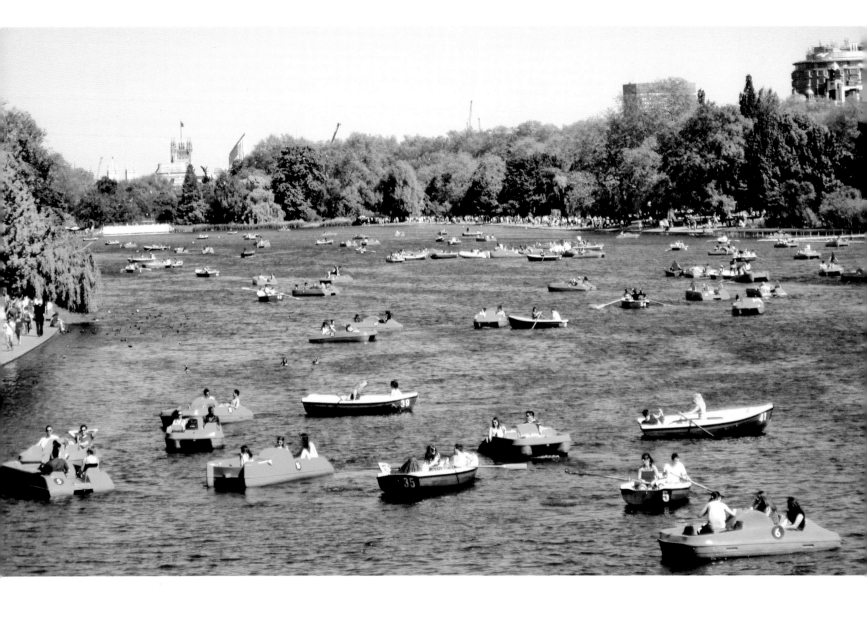

Above: Female triathletes fight it out in the swim portion of the 2011 Dextro Energy Triathlon – ITU World Championship Series London. (© William Price)

Below: Early morning preparations on the Serpentine. (© Debbie Brady)

Opposite: A profusion of pedalos on the Serpentine. (© Chris Walts)

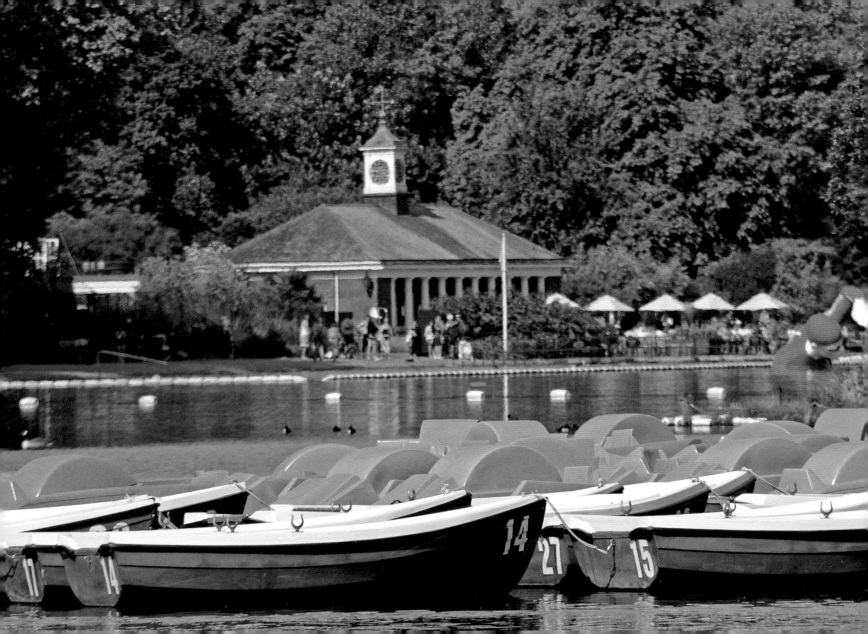

Above: 'Silence is golden.'

Below: 'Boris Bikes' in Hyde Park. The Barclays Cycle Hire is a popular public bicycle hire scheme in London. The bikes are now popularly known as 'Boris Bikes', after Boris Johnson, who was the Mayor of London when the scheme was launched.

Opposite: The Lido Pavilion. (© Debbie Brady)

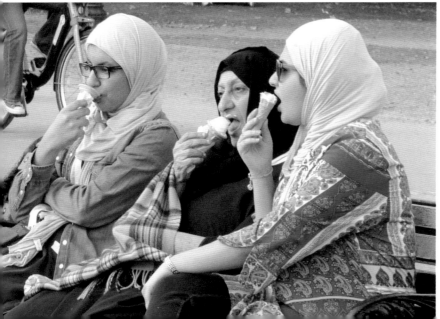

Above: Where once horses with carriages and cars were the domain of those who promenaded in Hyde Park, the 'Boris Bike' now dominates the Row and rides in Hyde Park.

Below: Chilling on a Sunday afternoon.

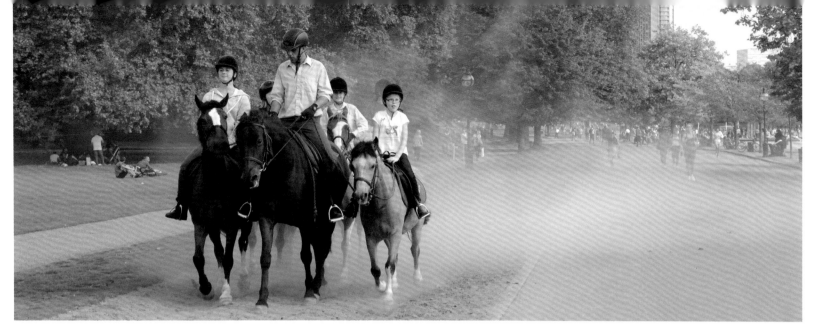

Above: A Sunday afternoon ride with the Hyde Park Stables, who are a common site in the park.

Right: 'Please sir, can I have some more?' (© Debbie Brady)

Above: Riders from the Household Cavalry Mounted Regiment. The regiment has been based (in various forms) at Hyde Park Barracks, Knightsbridge, since 1795.

Below: Lovers in the park. (© Debbie Brady)

Above and below: Relaxation in the park. (© Debbie Brady)

Above: Another exhausting day in the People's Park for Holly, Ellie and Ashley.

Left: A lazy Sunday afternoon. (© Debbie Brady)

Opposite: Winter Wonderland invades the park.

NOTES

Introduction

1. Evelyn Cecil, the Hon. Mrs; *London Parks and Gardens*, Archibald Constable, London, 1907
2. *Ibid.*
3. Davies, Hunter; *A Walk Round London's Parks – A guide to its famous open spaces*, Arrow Books Ltd, London, 1983
4. Scammell, Arthur; *Cheapside to Arcady*, Andrew Melrose Ltd. London, 1917
5. *Ibid.*

1 A Royal Hunting Ground

1. Larwood, Jacob; *The Story of the London Parks*, Chatto and Windus, London, 1874
2. *Ibid.*
3. Dancy, Eric; *Hyde Park*, Methuen & Co Ltd, London, 1937
4. Larwood, Jacob; *The Story of the London Parks*, Chatto and Windus, London, 1874
5. Norden's '*Survey of Middlesex and Hertfordshire*', 1596, p.19
6. Larwood, Jacob; *The Story of the London Parks*, Chatto and Windus, London, 1874
7. Tweedie, Mrs Alec; *Hyde Park – Its History & Romance*, Besant and Co. Ltd, London, 1908
8. Larwood, Jacob; *The Story of the London Parks*, Chatto and Windus, London, 1874
9. Butler; *Hudibras*, Part II, Canto 2
10. Larwood, Jacob; *The Story of the London Parks*, Chatto and Windus, London, 1874
11. Several Proceedings of Parliament, April 27–May 4, 1654
12. Westminster, 16 October 1654. N.S; Dutch Ambassadors letter to the States-General
13. Dancy, Eric; *Hyde Park*, Methuen & Co Ltd, London, 1937
14. Larwood, Jacob; *The Story of the London Parks*, Chatto and Windus, London, 1874
15. Dancy, Eric; *Hyde Park*, Methuen & Co Ltd, London, 1937
16. Larwood, Jacob; *The Story of the London Parks*, Chatto and Windus, London, 1874

2 A Royal Park for the People

1. The London Post, December 16, 1699
2. Tom Brown's Amusements for the Meridian of London, p54, 1700
3. The Spectator, May 1, 1711
4. Dancy, Eric; *Hyde Park*, Methuen & Co Ltd, London, 1937
5. Larwood, Jacob; *The Story of the London Parks*, Chatto and Windus, London, 1874
6. *Ibid.*
7. London Journal, September, 26, 1730
8. London Spy Revived, December 6, 1736

9. Lord Hervey's Letters, vol. i. p.189
10. London Spy Revived, September 23, 1737
11. Larwood, Jacob; *The Story of the London Parks*, Chatto and Windus, London, 1874
12. *Ibid.*
13. 'No sooner does he walk into the Senate, than he singles out and marks down each one of us.' – Cicero, *In Catilinam*
14. Dancy, Eric; *Hyde Park*, Methuen & Co Ltd, London, 1937
15. *Ibid.*
16. Larwood, Jacob; *The Story of the London Parks*, Chatto and Windus, London, 1874
17. Dancy, Eric; *Hyde Park*, Methuen & Co Ltd, London, 1937
18. *Ibid.*
19. Summerson, John; *Georgian London*, Pleiades Books, London, 1945
20. *Ibid.*
21. Evelyn Cecil, The Hon. Mrs; *London Parks and Gardens*, Archibald Constable & Co. Ltd. London, 1907
22. *Ibid.*
23. *Ibid.*
24. Dancy, Eric; *Hyde Park*, Methuen & Co Ltd, London, 1937
25. https://www.royalparks.org.uk/parks/hyde-park/things-to-see-and-do/speakers-corner
26. http://www.huffingtonpost.com/lewis-krell/post_6229_b_4314582.html

3 The Development of Kensington Gardens

1. Davies, Hunter; *A Walk Round London's Parks – A guide to its famous open spaces*, Arrow Books Ltd, London, 1983
2. Rabbitts, Paul; *London's Royal Parks*, Shire Publications, Oxford, 2014

4 Architecture and Artefacts

1. The Royal Parks; *Buildings and Monuments in the Royal Parks*, London, 1997
2. Rabbitts, Paul; *London's Royal Parks*, Shire Publications, Oxford, 2014
3. The Royal Parks; *Buildings and Monuments in the Royal Parks*, London, 1997
4. Rabbitts, Paul; *London's Royal Parks*, Shire Publications, Oxford, 2014
5. The Royal Parks; *Buildings and Monuments in the Royal Parks*, London, 1997
6. *Ibid.*
7. *Ibid.*

BIBLIOGRAPHY

Brace, Marianne and Ernest Frankl; *London Parks and Gardens*, The Pevensey Press, Cambridge, 1986

Church, Richard; *London's Royal Parks, An Appreciation.*, HMSO, 1993

Conway, Hazel; *People's Parks, The Design and Development of Victorian Parks in Britain*, Cambridge University Press, Cambridge, 1991

Conway, Hazel; *Public Parks*, Shire Publications Ltd, 1996

Dancy, Eric; *Hyde Park*, Methuen & Co Ltd, London, 1937

Davies, Hunter; *A Walk Round London's Parks – A guide to its famous open spaces*, Arrow Books Ltd, London, 1983

Edgar, Donald; *The Royal Parks*, W. H. Allen, London, 1986

Evelyn Cecil, the Hon. Mrs; *London Parks and Gardens*, Archibald Constable, London, 1907

Larwood, Jacob; *The Story of the London Parks*, Chatto and Windus, London, 1881

Lasdun, Susan; *The English Park, Royal, Private and Public*; Andre Deutsch Ltd, London, 1991

Rabbitts, Paul; *London's Royal Parks*, Shire Publications, Oxford, 2014

Rasmussen, Steen Eiler; *London: the Unique City*, MIT Press, Cambridge, 1934

Scammell, Arthur; *Cheapside to Arcady*, Andrew Melrose Ltd. London, 1917

Summerson, John; *Georgian London*, Pleiades Books, London, 1945

Tait, Malcolm and Edward Parker; *London's Royal Parks*, The Royal Parks Foundation, 2006

The Royal Parks; *Buildings and Monuments in the Royal Parks*, London, 1997

The Royal Parks; *Hyde Park Management Plan – 2006-2016*

Tweedie, Mrs Alec; *Hyde Park: Its History and Romance*, Besant and Co. Ltd, London, 1908

Weir, Alison; *Henry VIII King and Court*, Pimlico, London, 2002

Williams, Guy; *The Royal Parks of London*, Constable, London, 1978

Opposite: Early autumn in Hyde Park.

The true essence of a people's park. (© Debbie Brady)